CHALK ART
MANGA

CHALK ART MANGA

A STEP-BY-STEP GUIDE

DANICA DAVIDSON
ILLUSTRATED BY RENA SAIYA

Skyhorse Publishing

Skyhorse Publishing books may be purchased in bulk at special discounts for sales promotion, corporate gifts, fund-raising, or educational purposes. Special editions can also be created to specifications. For details, contact the Special Sales Department, Skyhorse Publishing, 307 West 36th Street, 11th Floor, New York, NY 10018 or info@skyhorsepublishing.com.

Skyhorse® and Skyhorse Publishing®
are registered trademarks of Skyhorse Publishing, Inc.®, a Delaware corporation.

Visit our website at www.skyhorsepublishing.com.

10 9 8 7 6 5 4 3 2 1

Library of Congress Cataloging-in-Publication Data
is available on file.

Cover design by Kai Texel
Cover illustrations by Rena Saiya

Print ISBN: 978-1-5107-7189-5
Ebook ISBN: 978-1-5107-7190-1

Printed in China

CONTENTS

INTRODUCTION: CHALK AND MANGA

Chalk and manga are two beloved forms of art, and now they're together at last. Many kids (and adults!) love to pull out some chalk and make pictures on their driveway or sidewalk. There's nothing quite like turning your driveway into a work of art on a sunny day. Even though the chalk will soon disappear, making this kind of art is soothing and unique, and it can still be captured forever by photography. The stress of achieving perfection—like with pen art—evaporates by wiping or washing away any errors.

Manga are Japanese comic books, and they're popular all around the world. Many of them are then turned into anime, or Japanese animation. In Japan everyone from kids to elderly people read manga, and its popularity continues to spread. Manga are popular for their eye-catching artwork, their thrilling stories, and their relatable characters. Traditionally, manga has been made with pen and paper, and more recently many people create manga on their computer or tablet. In this book, we will concentrate on the art side of manga characters as opposed to the storytelling. Whether you're doing a simple drawing on your sidewalk or doing advanced manga characters for onlookers at an anime convention, you have the tools and know-how to bring these characters to life!

In this book we're going to concentrate on how to work with chalk on outside surfaces. (Please first make sure you have permission to work on particular sidewalks. And please don't draw in the street, where it can be dangerous!)

Note: We'll let you know the original size of each artwork in case that's helpful as a reference, but you don't have to copy the size. This sample drawing of a heart, below, is three inches wide and three inches high.

While some aspects may be tweaked, we are going to do all the drawings with the following general steps:

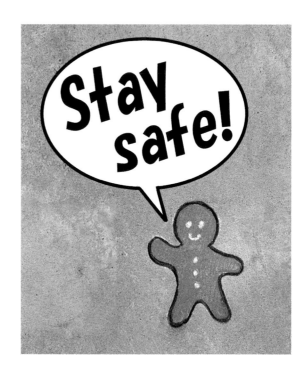

Step 1: Draft using white chalk. Take a piece of white chalk to draw the outline of the shape or character you're going to make. In this case, we're making a heart.

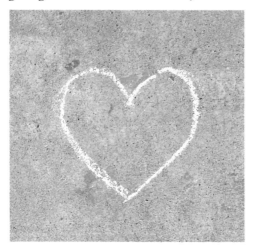

Step 2: Pick the chalk color(s) you want. In this book we'll be showing you specific colors for each drawing, but always feel free to use whatever colors you want. If you're not sure what colors to use, you can follow our color choices. It can be helpful to first trace the color on the inside of the white line before coloring it in, because it keeps you from coloring too far. However, you can also wait until after the next step to trace inside the outline. So here you can see an outline of pink on the inside of the white line.

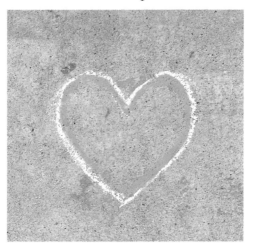

Step 3: Next, fill in the drawing with the chalk. It's better to use the chalk in straight, back-and-forth lines instead of coloring randomly. See the next heart picture for how this looks completed. To see what we mean by back-and-forth lines, check out "How to Color with Chalk" on page xiv.

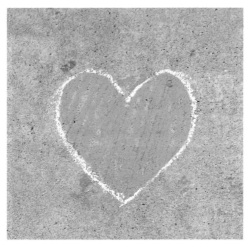

Step 4: Smudge the chalk. Put your finger into the chalk and move it around to smooth it out. Not only does smudging take away patchy looks that might appear in pavement, but it can also help you blend colors. Smudging can make your artwork look really fancy and smooth! If you don't want to get your fingers dirty, you can wear gloves to smudge. You also don't have to smudge if you don't want to, but it will help make your picture pop, and we will be using the smudging process in all our examples.

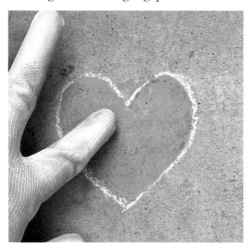

Step 5. After you smudge, you might want to add a little more color if there's not enough. When you work on an uneven surface, the chalk might be thinner in some places than others. Here's where you can easily fix that. After that, you can smudge again if needed.

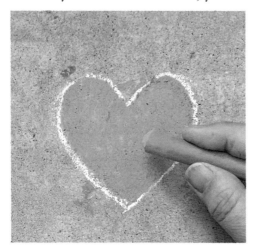

Step 6: After you're done smudging, draw black lines over the original white lines. This helps bring out the picture more and also makes it look more like manga, because manga characters are outlined in black.

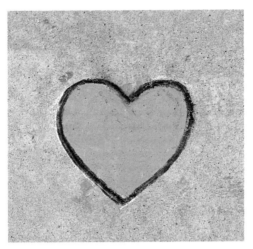

Step 7: As the final step, you can add some white chalk in specific locations to get a shiny look. For example, you can put some white in a person's hair to make it look as if it's shining in the sun. With this heart, you can see where to put white lines first on the left side, then on the right side.

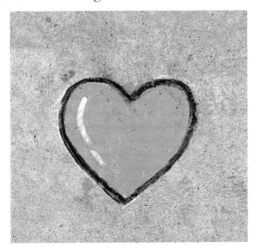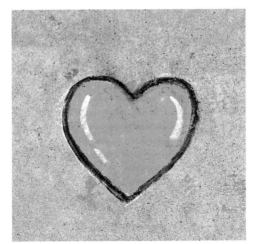

And with those steps, you will have your chalk art! Feel free to follow exactly as we show the steps, or just use the steps as a springboard for you to get creative and try new things if you want to.

We start with simpler characters and work our way up to more complex characters. For the more complex characters, you might want to draw your character first on paper, and then use that to guide you while you work with your chalk. Drawing it this way first can help you with proportions and balance. For example, if you draw a head that's too big, it can help to fix it at this point so you don't also draw a head that's too big with your chalk art.

We'll show you examples of what it could look like on paper, with pictures done in colored pencils. Another reason why it might be good to draw something on paper beforehand is because chalk art is done outside, and the weather may change. But if you already have a sketch, that can speed up your artwork so you can finish it before it gets dark or rainy.

After drawing on paper, we move to a rough sketch on the pavement, and this is also just so you have a general idea of proportions and shape. Don't worry if the rough sketch isn't perfect, though. When we get to the more detailed steps, you'll see how to maximize the potential of your work.

How to Color with Chalk

Many people color in a zigzag motion when they color with chalk. While you may color however you want, doing it this way makes it easier to accidentally go over the lines of the character if you're coloring quickly. So we don't recommend doing this.

To avoid that, the lines are drawn like this for the art in this book. After the lines are drawn, smudge them with a bare finger or a glove to spread the chalk evenly. If you want thicker color, draw thicker lines.

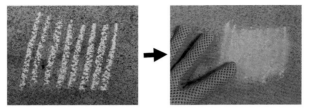

Sometimes the streaks might still stand out even after you smudge them.

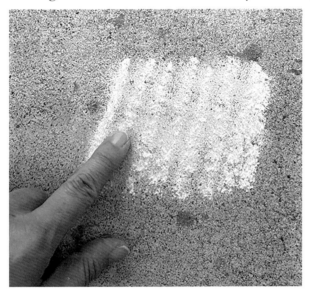

In that case, you can draw a zigzag line horizontally across the vertical lines in addition to what you've already done, then smudge it again. Filling in extra chalk is the only time using zigzag lines is recommended.

The first lines *The second zigzag* *Smudging*

 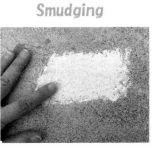

Blending Colors

Sometimes we're going to blend different colors, which is very fun to do with chalk. As a reference, the apple we're going to use as an example is about four inches wide and four inches high.

1. You start with the outline of the apple—and a line for the stem.

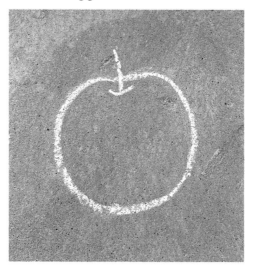

2. Outline the top section red. Outline the bottom section green. Leave space between them.

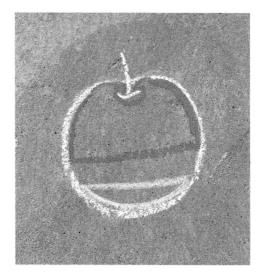

3. Color the red and the green sections.

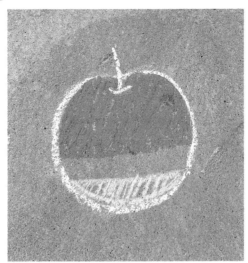

4. Put two red lines close to the green, but not touching the green.

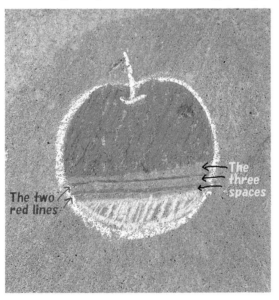

5. Fill in green between the two red lines you made.

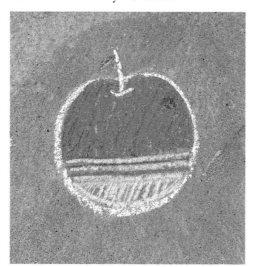

6. Smudge the colors. Use one finger for red and another finger for green, because you don't want the whole apple blended. But in the middle you can blend the colors together.

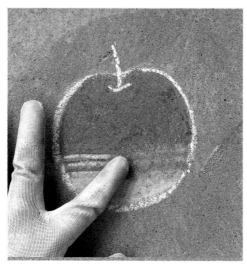

7. You can see here how it has a blended look where the red and green gradually combine. You'll see this technique with some characters in the book, and you can also do it on your own.

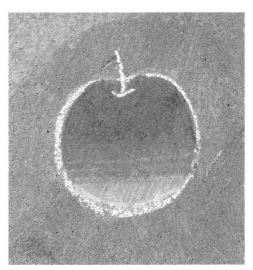

8. Outline the apple with black.

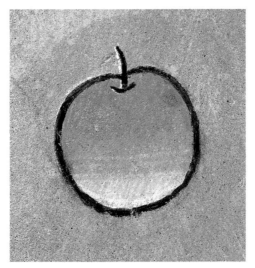

9. As a final touch, add some white for a shiny look.

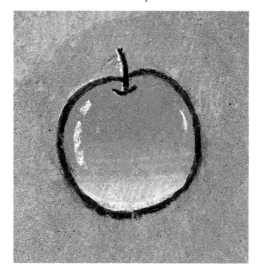

Some Other General Rules

When coloring and smudging multiple colors, it's generally best to start with the lighter colors. If you do the dark colors first and then the light colors, it's easier to accidentally smudge the darker color into the lighter color, messing it up. There are exceptions to this, like when you add white for a shiny look at the very end.

It also helps to pay attention to what direction you draw and color in. If you're right-handed, start on the upper left and make your way over to the right. If you're left-handed, start on the upper right and make your way over to the left. This makes it less likely your hand will smear the chalk.

If a curved line is really long, it can be difficult to draw all in one stroke. For long lines, it's recommended you might want to connect shorter curved lines, like you see in the image on right.

〈**Where you should start drawing**〉

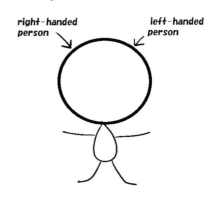

Mistakes Happen, and That's Okay

What happens if you make a mistake? That's okay! In creating this book, we used an ordinary dish-washing sponge (the kind with bristles on one side) to wipe away any extra chalk and to clean fingers between smudging different colors. You can use either side of the sponge. It's easier to erase the whole thing than one part, though. So if you erase just a part, make sure you don't accidentally erase more than you meant to.

It's also important to remember that no one becomes great at art immediately. It takes practice. The biggest reason to make chalk art is because it's fun to do, so don't get upset if it takes some time.

It's also normal for chalk art to look a little "rough" on the pavement. Chalk art might look better from a distance or on camera. You can see the difference between this close-up and a more distant shot. But this is also true for other artwork. For example, if you come too close to a painting, it might not look the same as when you step back and see the full image. So there's no need to worry about this.

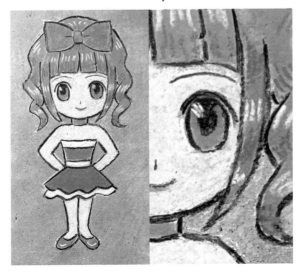

Types of Chalk

There are different kinds of chalk out there. Chalkboard chalk is, like it sounds, used on chalkboards primarily. Pastels are sometimes confused with chalk, but they're not the same thing. Pastels are made differently and are sometimes more expensive. All of the art in this book was made with good old-fashioned sidewalk chalk you can get from your local store or online. The one exception is that charcoal was used to outline the drawings, though black chalk can work as well. You can get artists' willow charcoal sticks from an art store or online. This isn't to be confused with the charcoal you use for grills! It looks like this.

Another option some people enjoy is making their own sidewalk chalk. There are books and tutorials online about how to do this. Making your own chalk can also let you get creative, because you can make the chalk in different colors, or add glitter.

You might want to test out any chalks you have on the pavement first before you use them in your artwork.

Chalkboard vs Pavement

All of the artwork in this book is done outside. While chalk art exists in Japan, there it's typically done on chalkboards instead of pavement or driveways. If you want to make this art on chalkboards, that's totally fine, too.

Because pavements and chalkboards are different, the artwork is slightly altered as well. After all, chalkboards are a different color and texture from pavements. So just keep that in mind if you want to try this on the chalkboard.

Other Tools

GLOVES

You can use your bare fingers, or you can use gloves when smudging. Garden gloves with thin rubber padding work better for smudging than 100 percent cotton gloves.

OLD CUSHION

If you spend a lot of time working on your chalk art, it might hurt your knees. So you might want to bring an old cushion or pillow out to put under your knees as you work. Be careful not to accidentally smear your chalk if you move the cushion!

Also, be careful with your sleeves—if you have long, loose sleeves, you might accidentally stain it with chalk and erase some art while you're at it, like this example with the ninja.

You don't need this, of course, but a camera might be nice to have around so you can take pictures of your artwork.

How to Draw Manga Style

When you draw characters, it's helpful to understand the notion of "how many heads tall a character is." This can help you with your proportions. First look at the chibi girl below. She has a little more than two heads equal to her height. These are chibi proportions, because chibi characters in manga and anime have big heads and little bodies.

But for a character like the magical girl, she is equal to about five heads. Generally speaking, if the character is equal to about eight or nine heads, they look tall and like an adult. The five heads make the magical girl look like a teenager. The two heads make the chibi girl, well, chibi. The human characters in this book average about five heads.

〈proportion〉

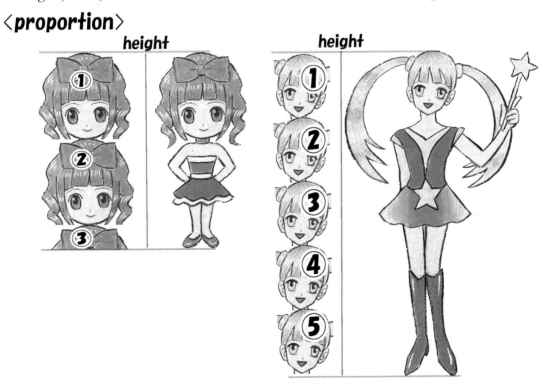

Like proportions, eyes are an important part of the manga look. The younger and more innocent the character, the bigger and rounder the eyes. If a character is older, or more mature, or more serious, their eyes are still usually bigger than a real person's eyes, but not by as much. The eye size can really bring out the personality of the character!

The easiest eye drawings in the book are the candy eyes. They are drawn with only black and some white shiny parts. The white shiny parts make the eyes look much more alive.

In this book you can also see eyes that are a little more complicated. Here's how to draw that kind.

Fill the insides . . . **Draw the outlines of the eyes . . .** **Add white parts . . .**

Fill the insides of the eyeballs and color white around them.
Draw the outlines of the eyes and the black parts as shown in the image.
Add white parts as shown in the image.

Now let's look at noses and mouths.

In manga, young characters have very small noses and mouths. Sometimes the noses can just be dots, especially for girls. When the characters are young, they also usually have small mouths instead of big and realistic ones. Generally these mouths are small and simple, especially for girl characters.

Mouth from the front

Mouth from a 45 degree angle

Open mouth

There are some differences between manga characters in comic books and the manga characters you make in chalk art. Manga characters on paper will be quite small, but with chalk art, you can make them bigger. Also, manga is usually in black-and-white, with only covers and special pages done in color. The fun thing about chalk art is you can use all sorts of colors.

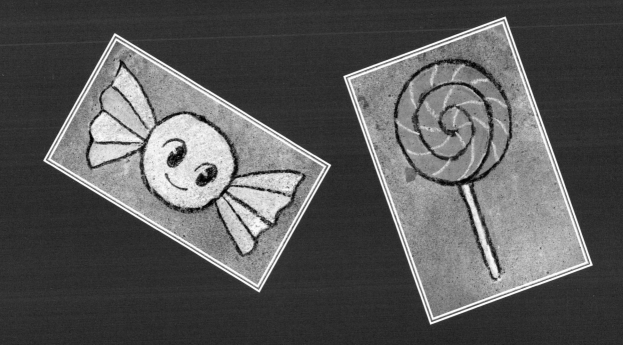

KAWAII FOODS

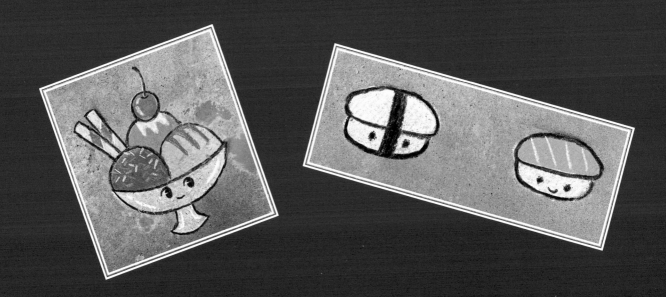

KAWAII CANDY

"Kawaii" is the Japanese word for "cute," and it's also a popular style of art you can find in some manga. Food and especially sweets are great for making kawaii art, so let's start with a few examples. For our first drawing, we're going to create hard candy in a wrapper. As a reference, the drawing you see here is about twelve inches wide and six inches high, but yours can be whatever size you want.

1. For your outline, begin with a circle in the middle. If you want a perfect circle, you can outline a circular object like a plate. Then you do the wrapping on each side of the circle. On each side of the wrapping, have a few little waves.

2. Go back to the waves you made, and draw lines inside, from the edges of the circle to the ends of the wrapper. This will give the wrapper different sections.

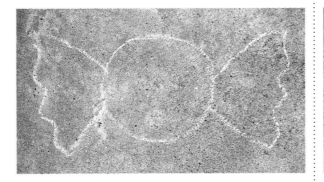

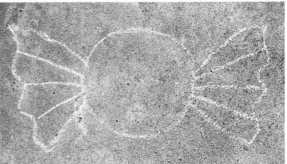

3. Color in the circle, and two sections of the wrapper. Do yellow, back and forth lines. Do not have the two sections touch each other.

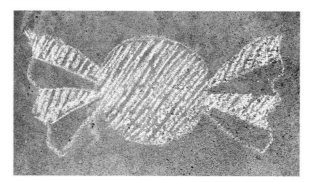

4. Go back to the sections of the wrapper that you didn't color in. Color those green.

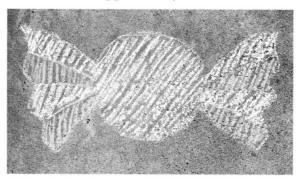

5. Smudge the chalk. It's generally better to begin smudging with the lighter color, so begin with yellow, then do green. If you smudge with your fingers, make sure you wipe your fingers with a sponge before you smudge the other color.

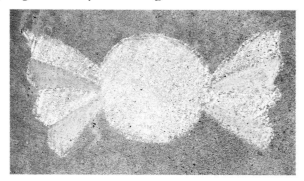

6. Outline everything in black. If you are right-handed, please start outlining from the left wrapper, then move on to the circle, and then the right wrapper. If you are a left-handed person, please do this the opposite way. This keeps you from smearing anything with your hand.

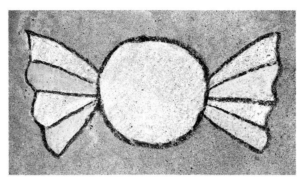

7. Put a face on the candy. It's important to save the face for the end. If you draw the face in earlier using black chalk and smudge, it can just mess up your lines and get black chalk all over the face. So don't add this until you're happy with how everything else has turned out.

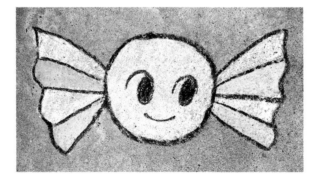

8. Add some white to the eyes to give them a shiny look.

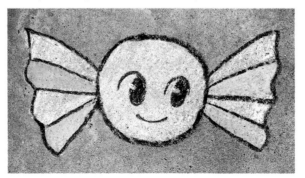

KAWAII SUSHI

Sushi is a popular and traditional food found in Japan, but people all around the world love it, too! As part of our look at kawaii foods, let's make some adorable sushi. This kind is known as *nigiri*, and it has food (usually fish or other seafood) placed over balled rice. As a reference, the pieces of sushi are each about four inches wide and two inches high, but yours can be whatever size you want.

1. Start with two elongated outlines. It might look a bit like two eyes without any pupils. This is going to be the top part of the sushi, where the toppings are.

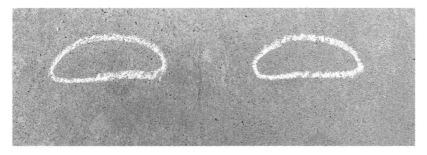

2. Draw the rice underneath the toppings. It will be slightly less wide than the toppings.

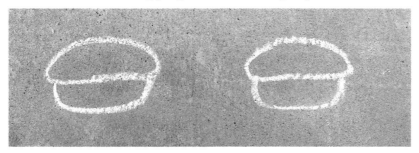

3. Add lines of color for the colors you're primarily using on the toppings. In this case, one is yellow and one is orange. The yellow is for Tamago sushi, and the orange is for salmon sushi. Many sushi are made with seafood, but Tamago sushi has a rolled egg omelet called Tamagoyaki on top of it.

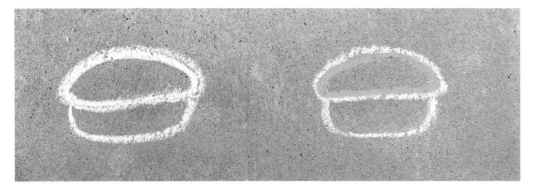

4. Fill in the rest of the color. The rice will always be white, but the toppings can come in different colors if you want to do something other than egg and salmon sushi.

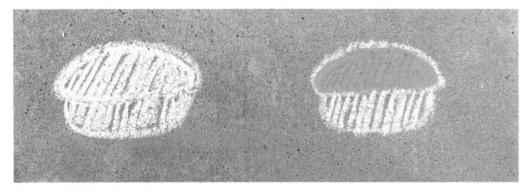

5. Smudge the colors. Smudge the white before you smudge the other colors.

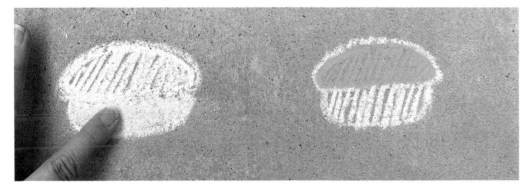

6. Add any extra chalk after smudging if needed.

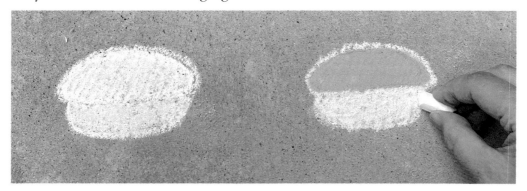

7. Outline the toppings in black chalk.

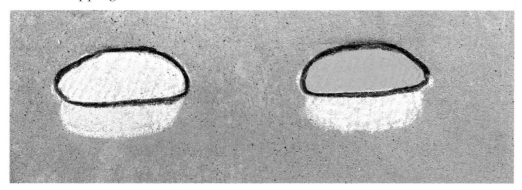

8. Outline the rice. A sponge is useful in case of a mistake.

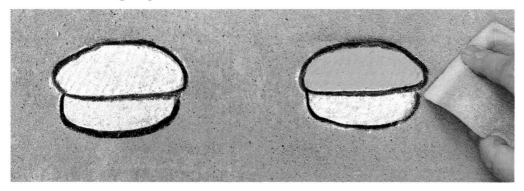

9. Put two black lines over the egg sushi. These are going to become a strip of nori sea-weed, which are used in some Japanese meals. The salmon sushi will have lined textures for the fish, and these are easily shown through a few lines over the top.

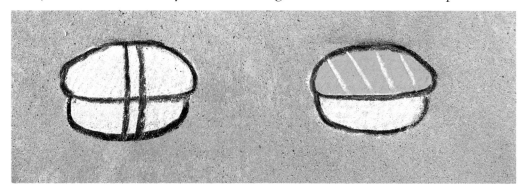

10. Color in between the black lines on the egg sushi to finish off the nori seaweed.

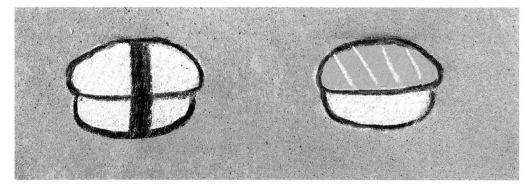

11. When you're happy with everything else, add little faces to the sushi!

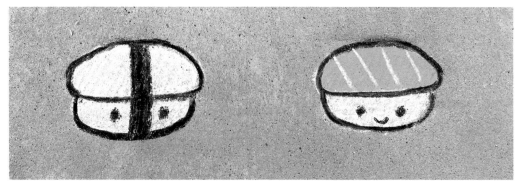

KAWAII LOLLIPOP

Let's continue the kawaii artwork with a kawaii lollipop. As a reference, the drawing you see here is about five inches wide and seven inches high, but yours can be whatever size you want.

1. Using white chalk, start with the outline for the lollipop. Put a big circle on top and a stick under it.

2. Fill the stick with white chalk. Color inside the circle with pink chalk.

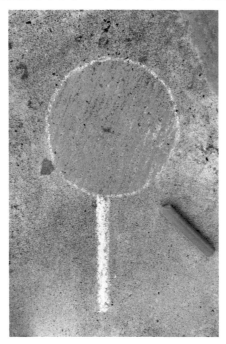

3. Smudge the pink chalk.

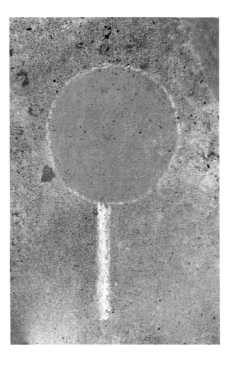

4. Outline the shape with black chalk.

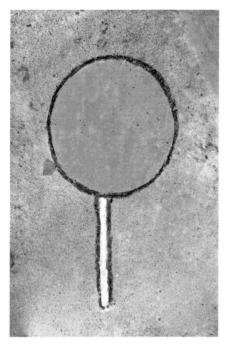

5. After you are happy with everything else, you can put a spiral of black chalk inside of the pink circle.

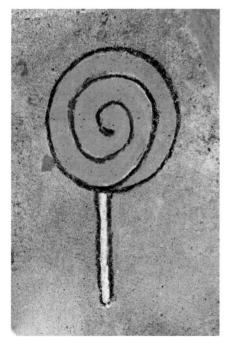

6. Start putting white lines inside the spiral. Make them each about the same distance apart.

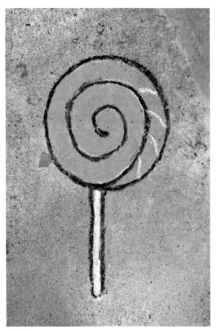

7. Continue to add the white lines. Watch how your hand moves so you don't accidentally smudge anything out of place!

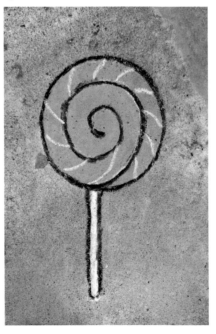

8. Pay attention to how the white lines go all around the spiral in the lollipop.

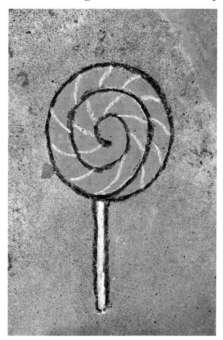

9. Finish the white lines and your lollipop is done! You can also add a face if you want, or leave it as is.

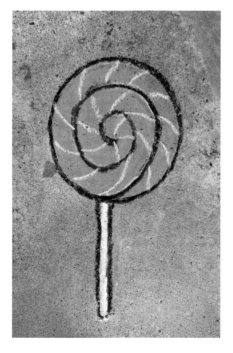

KAWAII ICE CREAM SUNDAE

Like other sweets, ice cream sundaes are great for a kawaii look. It's almost too precious to eat if it were real! As a reference, the drawing you see here is about ten inches wide and ten inches high, but yours can be whatever size you want.

1. Start with your outline with white chalk. The bowl that the ice cream sundae is in will have a shape like a crescent moon or a big, smiling mouth. Underneath that, draw the stand the bowl is on.

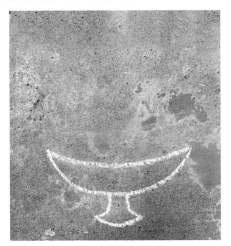

2. With your white chalk, put in three circles for scoops of ice cream.

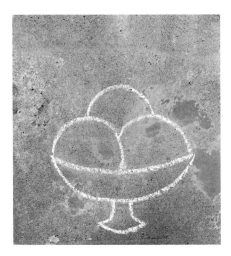

3. Take a little bit off the top on the middle ice cream scoop with your sponge. This gives you room to add a cherry.

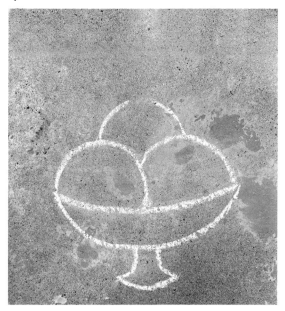

4. Now you can add your cherry on top. Draw a little circle and a line coming out of the center of the circle. You can also add two wafer sticks. Put two diagonal lines in the sticks so that each stick is divided into three sections.

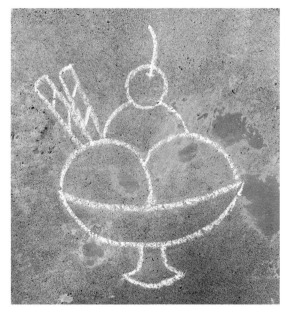

5. It's time to start coloring! The bowl is white, and you want to start with lighter colors. With the wafer sticks, start with the yellow on the outside, then do the brown on the inside. The ice cream scoop on the left has light brown chalk with a little bit of darker brown chalk streaks in-between. This is to make it look like chocolate. The middle scoop is pink for strawberry. The ice cream scoop on the right is green for mint. The cherry is red.

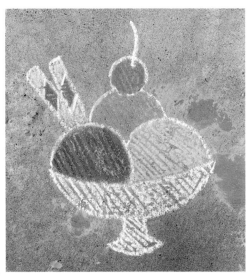

6. Smudge the colors. Start by smudging the light colors, then move on to the darker ones.

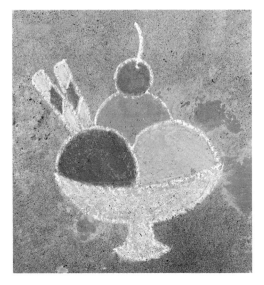

7. Outline everything with black chalk.

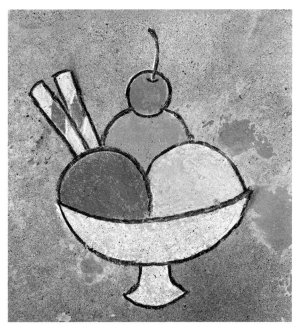

8. Add a couple white lines to the cherry to give it a shiny look. Also add white to the top of the strawberry ice cream for some icing. Put some streaks of brown over the mint ice cream for chocolate syrup.

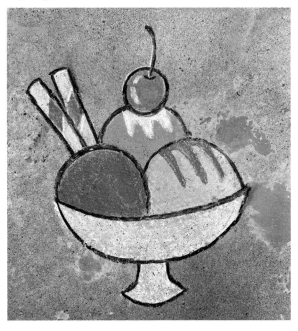

9. Put little streaks of blue, red, green, and yellow on the chocolate ice cream for sprinkles.

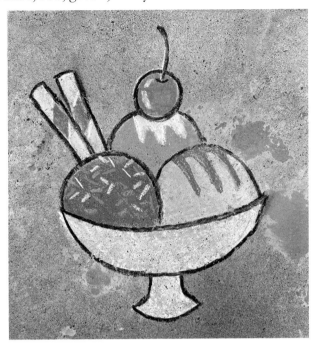

10. For extra effect, draw in a few stronger lines of white on the left and the right of the bowl, and on the left and the right of the stem it stands on. This makes it shine.

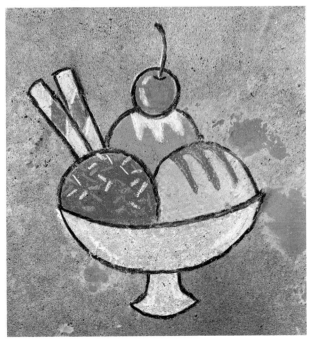

11. Add the eyes and mouth for the face.

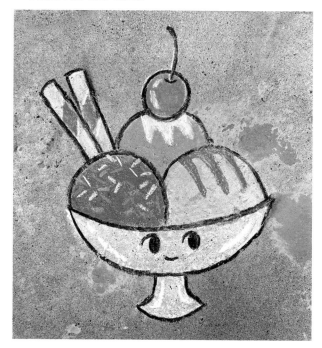

12. As a final step, put a line of white over each of the eyes so they have a shiny look.

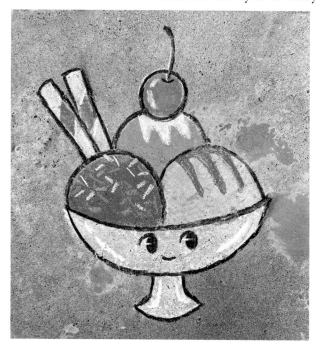

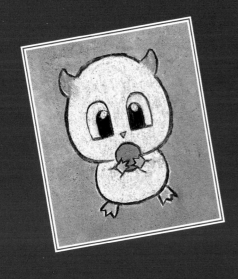

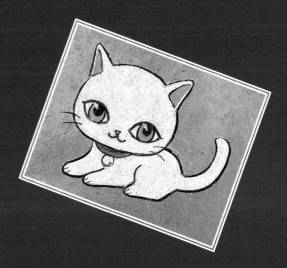

KAWAII ANIMALS

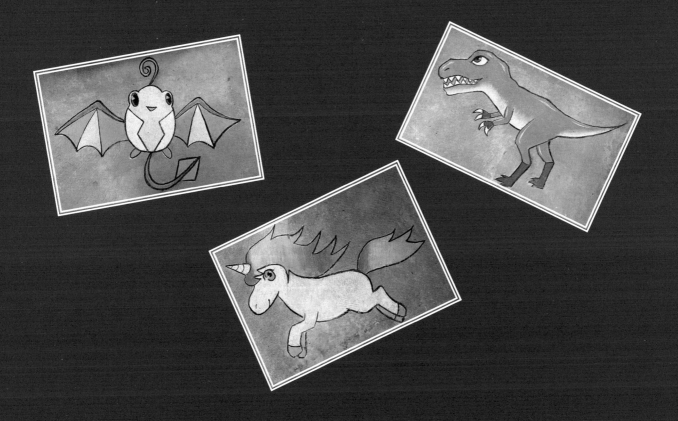

HAMSTER

Hamsters make cute pets, and they're also great to turn into manga characters! Let's draw a little hamster who's in the middle of eating. As a reference, the drawing you see here is about six inches wide and ten inches high, but yours can be whatever size you want.

1. First, you might want to draw out what you want on paper when we work on more complicated drawings. Then you can use this to guide you while you make your chalk drawing. You can also skip this and go straight to the chalk drawing if you feel comfortable.

2. Draw your basic sketch for the hamster in light white chalk. The head is bigger than the body. It will have big eyes and tiny ears, plus a little triangle nose between the bottom of the eyes. There are two feet it's standing on, and two feet holding a circle in front of its mouth.

3. Go back to the head and ears and make the chalk there more firm and clear.

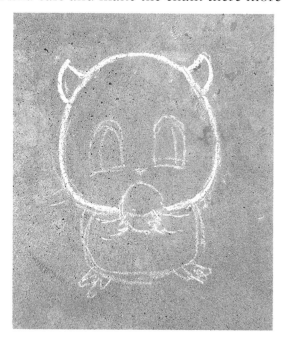

4. Start on the eyes. The pupil will take over most of the eye.

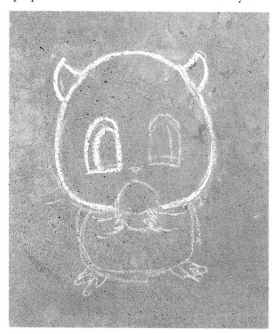

5. Repeat for the other eye.

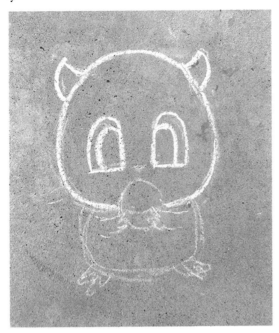

6. Go over the nose and the circle of food it's holding.

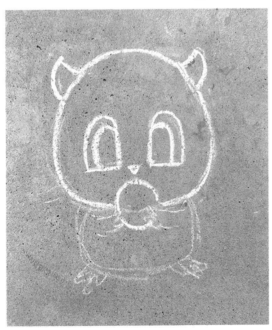

7. Complete the chalk outline for the main part of its body.

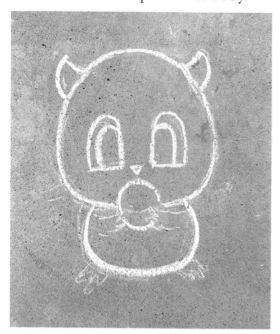

8. Fill out the chalk outline for its top legs. It has three little prongs to grip.

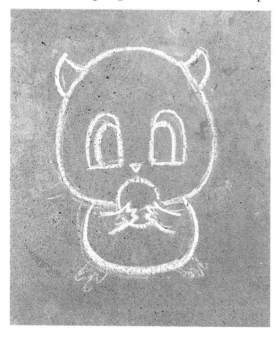

9. Fill out the chalk outline for its bottom feet. These will also have three little prongs.

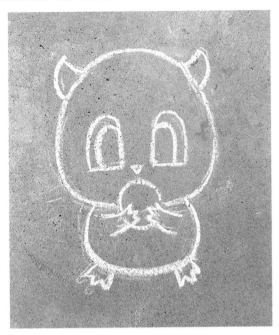

10. Color the head yellow and the ears brown.

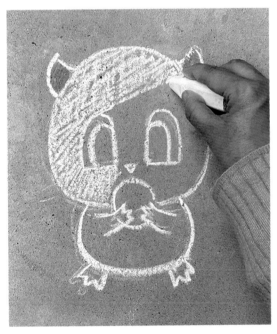

11. Finish the yellow across the face.

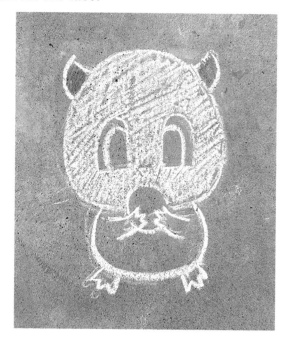

12. Color the rest of the body yellow.

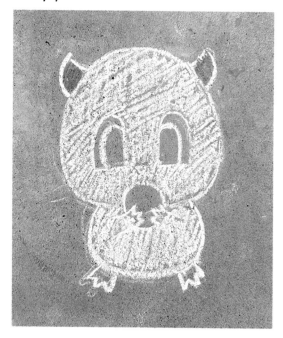

13. Smudge the yellow chalk.

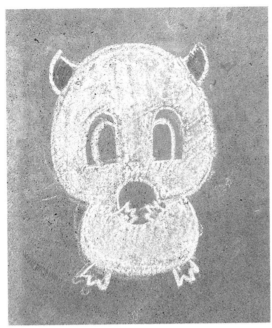

14. After you smudge, add more chalk if needed.

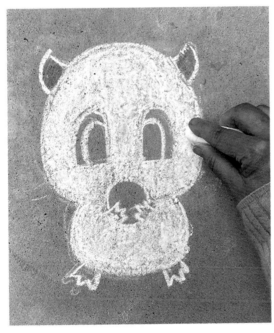

15. Here's what it looks like after adding more chalk.

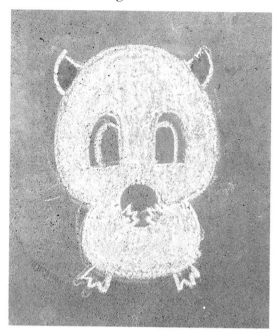

16. Fill in the whites of the eyes. Because it's a small area, you don't need to smudge. After you do the white, then you can outline the eyes in black. Color the feet pink. Because it's a small area, you also don't need to smudge here. Color the food.

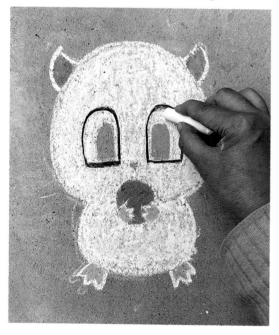

17. Outline the pupils with black chalk.

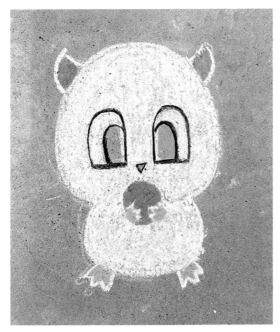

18. Outline the ears in black chalk. Use thicker lines than you did with the eyes.

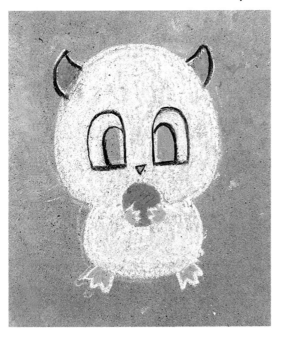

19. Outline the head with black chalk. Because the head is so big, make the outline thicker than you do for the eyes. Outlining the whole face at once would be hard, so take your time doing it in pieces.

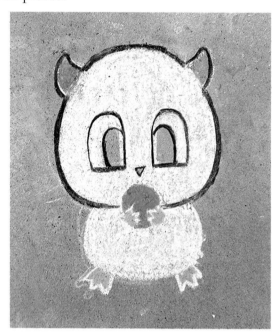

20. Outline the food and the feet around it with black chalk.

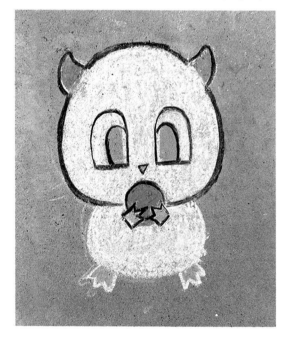

21. Outline more of the top legs.

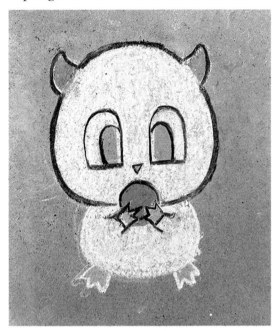

22. Outline the rest of the body and the feet.

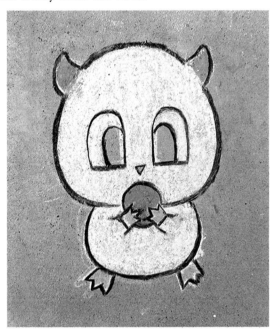

23. Smudge around the ears to make them connect with the head more naturally.

24. See how the ears look better connected to the head now.

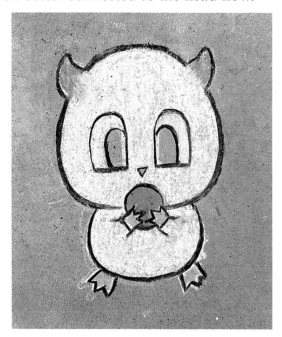

25. Color the pupils black. Leave small circles in each eye.

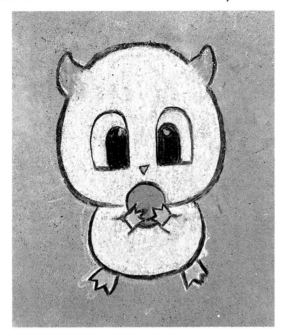

26. Carefully put white in the eyes for a shiny look. If you have any extra lines outside of it, erase with a sponge.

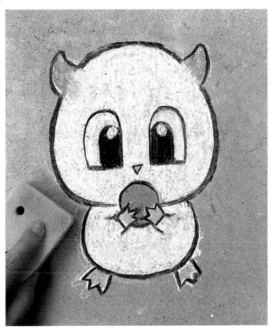

27. Your hamster is all done!

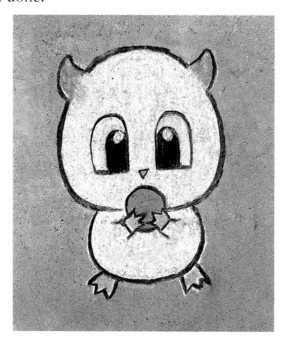

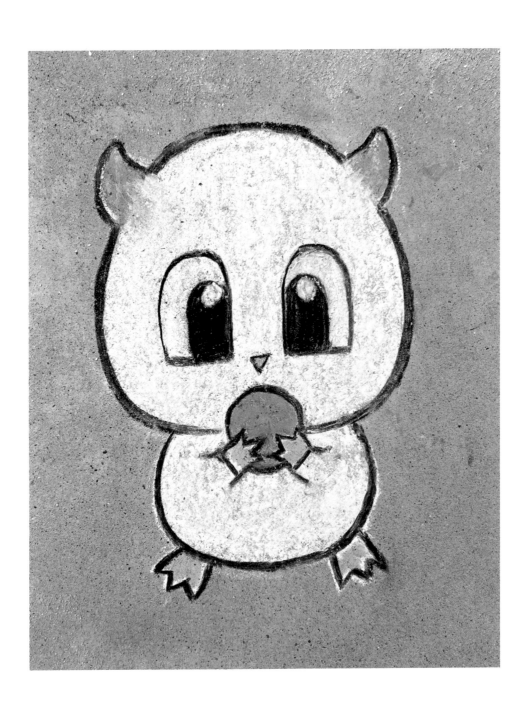

KAWAII CAT

Cats are very popular in manga, and in Japan. Let's make a beautiful cat with a collar and bell around her neck. As a reference, the drawing you see here is about eleven inches wide and eight inches high, but yours can be whatever size you want.

1. You can design the cat beforehand on paper so you know what to draw when you get out your chalk.

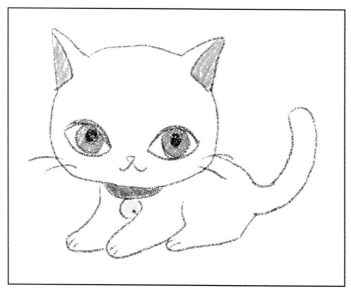

2. Begin with a rough sketch using white chalk. The cat's head will be bigger than her body, and she will also have very big eyes. She has a collar and three legs tucked under her. We can't see her fourth leg because of her position. Her tail is up in the air.

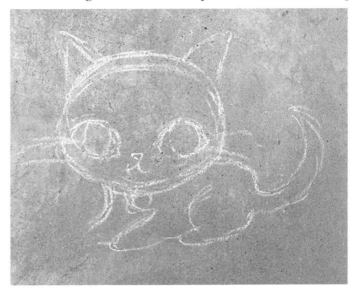

3. Fill in her large eyes with white chalk.

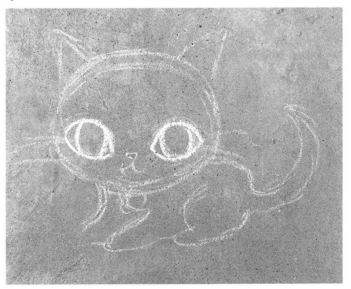

4. Her nose is an upside down triangle, with two curves under it for her mouth.

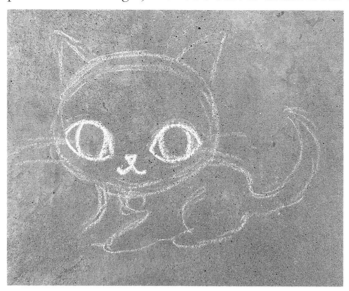

5. Her ears are two triangles.

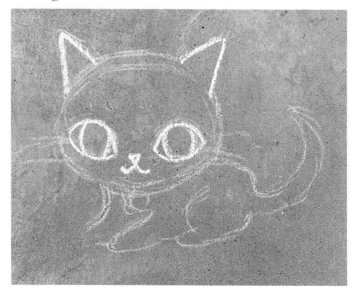

6. Outline her whole head. Add a line in each ear.

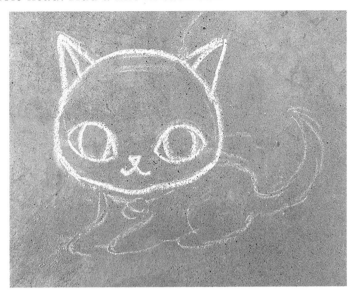

7. Outline her collar and bell.

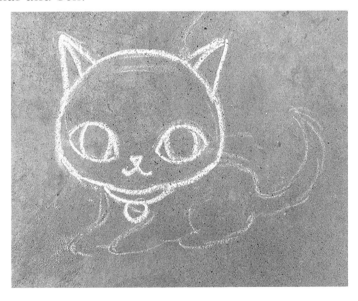

8. Draw one of her front legs.

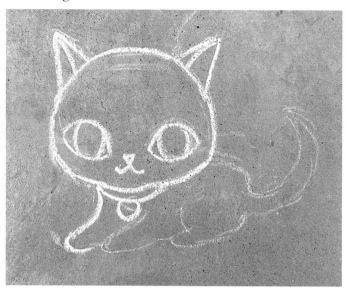

9. Draw her other front leg.

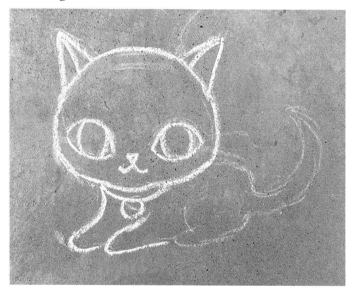

10. Draw her back leg.

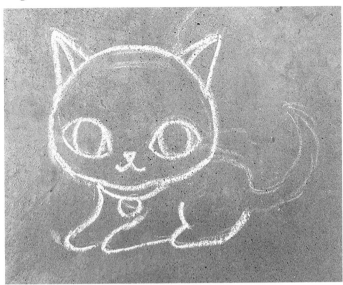

11. Finish outlining her in white chalk.

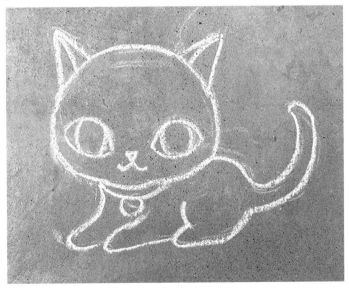

12. Color in her fur with white chalk.

13. Finish coloring her face. You can use gray chalk to bring back the nose and mouth.

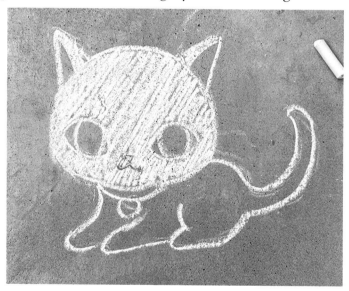

14. Use gray chalk for the lines of her legs so you can still see them as you color her white.

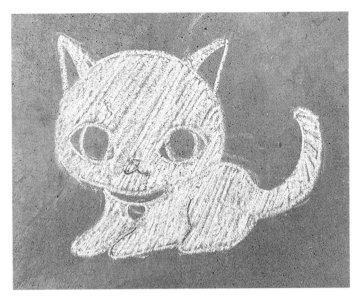

15. Smudge the chalk.

16. Smudge all the way around her, being careful not to touch the parts that aren't white.

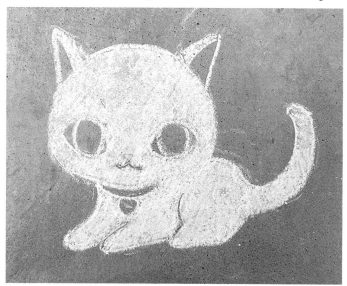

17. Add white chalk if the color looks too thin in any parts, and smudge again if needed.

18. Color bell yellow, and her inner ears pink, and her collar red. Because these are small areas, you don't need to smudge.

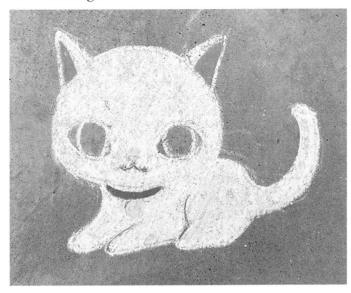

19. Outline the eyes in gray so they stand out more.

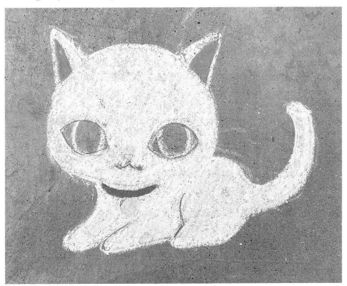

20. Color her pupils blue. The rest of her eyes are white, but the gray chalk clearly shows the shape of her eyes.

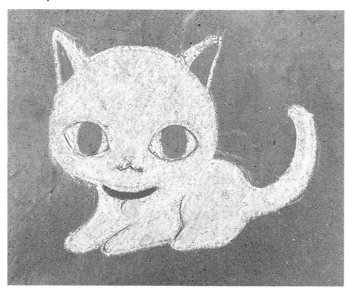

21. Outline her ears with black chalk.

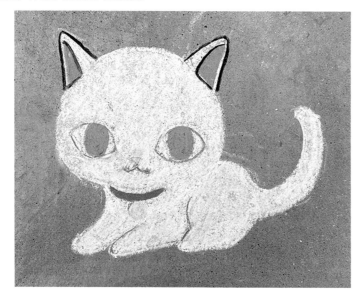

22. Outline her face with black chalk. It will be hard to do this all at once, so do it in small lines as you go around her face.

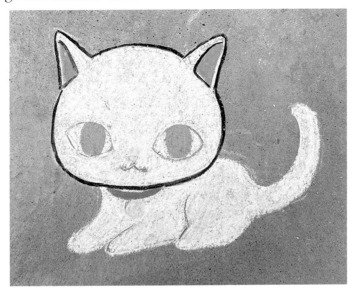

23. Outline her collar and bell. A line of black through the yellow will change it from a circle into a bell. At the end of the black line, add a dot of black.

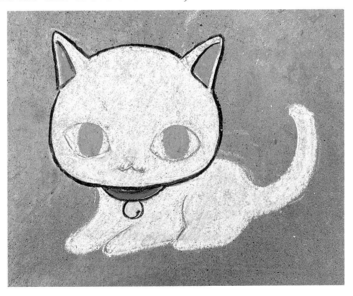

24. When you outline her eyes, make the upper eyelids thicker than the bottom ones.

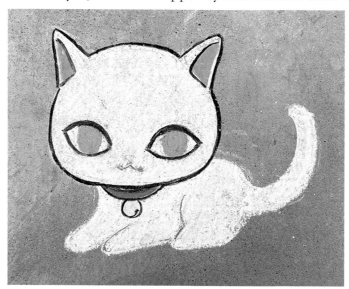

25. Carefully outline the pupils.

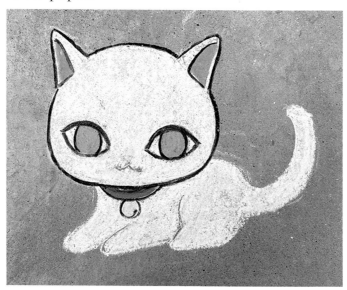

26. Outline the mouth and nose. Add black pupils on top of the blue for her eyes.

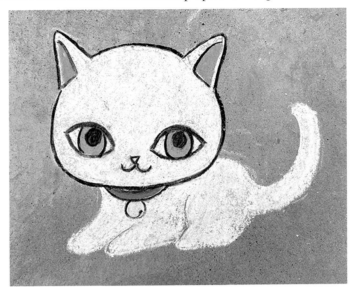

27. Outline the front feet and add two lines for her paws. The outline for the feet will be thicker than the lines for her paws.

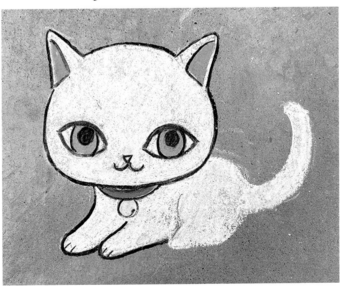

28. Outline her back and tail with black chalk.

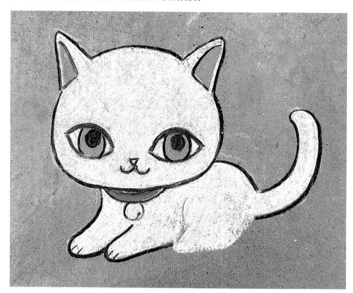

29. Finish outlining her and put in more black lines for her paws.

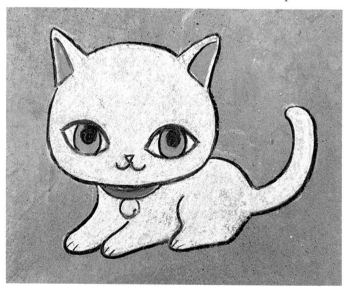

30. Add a bit of white on her pupils and irises to give a shiny look.

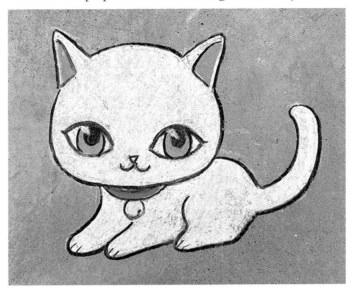

31. Add more white chalk if you need to.

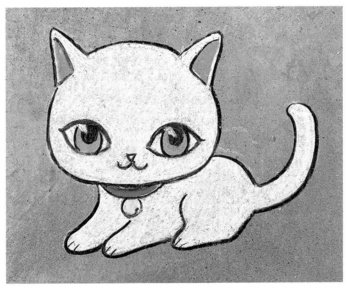

32. Add two whiskers on the left side of her face.

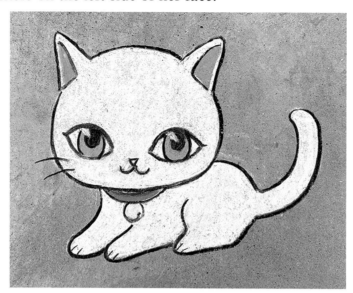

33. Add two whiskers on the other side of her face. Your Kawaii Cat is done!

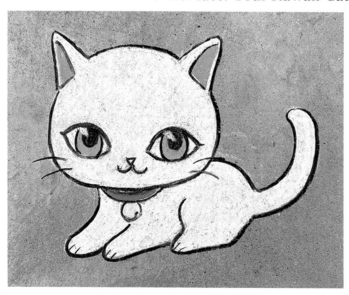

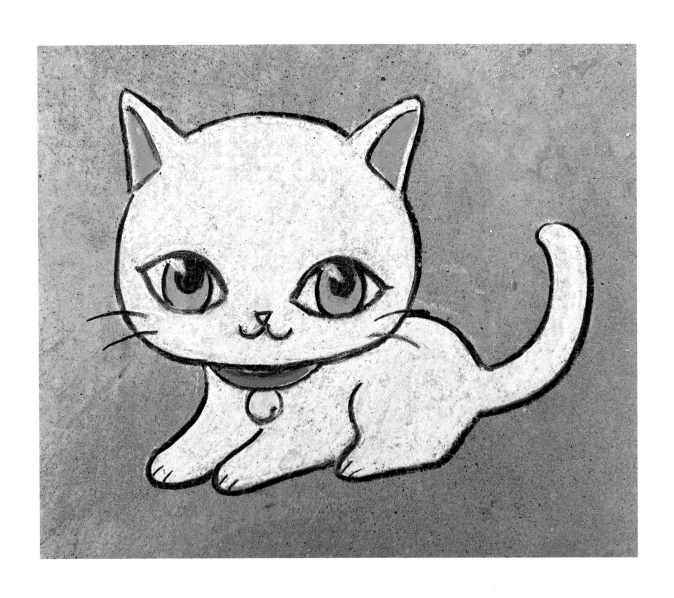

KAWAII UNICORN

Stories about unicorns aren't originally from Japan, but unicorns are popular enough that sometimes they make their way into the pages of manga. This unicorn has a mane and a tail of blended colors, a special trick you can do with chalk. As a reference, the drawing you see here is about twenty-eight inches wide and eighteen inches high, but yours can be whatever size you want.

1. Start by drawing out what you want on paper.

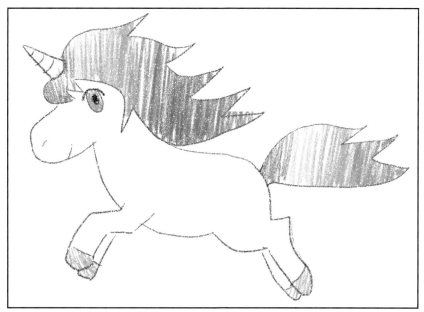

2. Do a rough sketch of the unicorn. The unicorn has a large head, big eyes, and a streaming mane and tail.

3. Concentrate on outlining the horn. It will have three lines going through it to make a spiral.

4. Draw more of the unicorn's body.

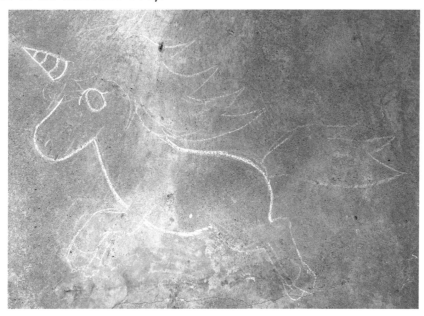

5. Draw the legs and hooves.

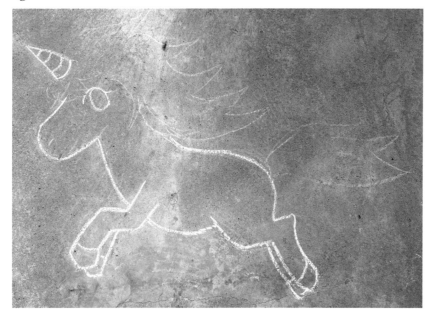

6. Draw the mane and tail. Because the unicorn is running, the mane and tail will be up and flowing.

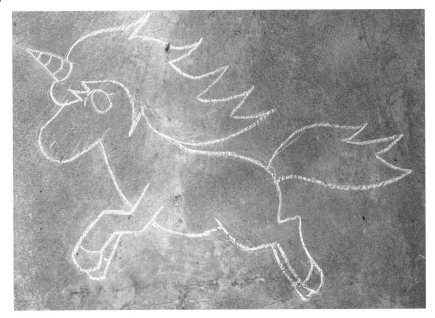

7. Start with lighter color by coloring the horn and body white. The only part of the body that is not white (aside from the mane and tail) are the legs in the background. Leave them alone for now.

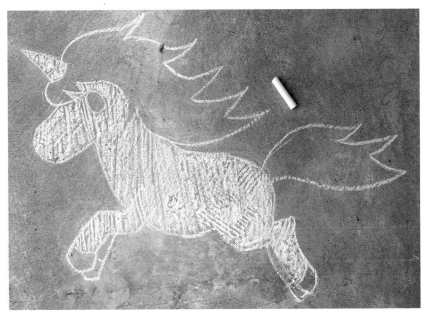

8. Smudge the white chalk.

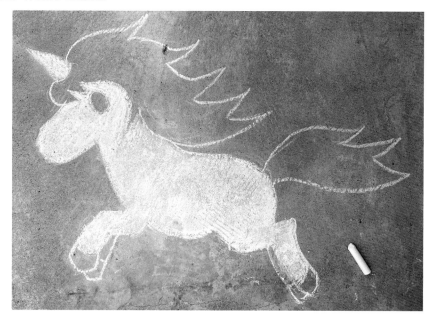

9. It's time to work on the rainbow mane and tail! Put a bit of space between each color for now. The colors for the mane are red, yellow, light green, dark green, blue, purple, red again, and orange. The colors for the tail are red, yellow, light green, dark green, and blue.

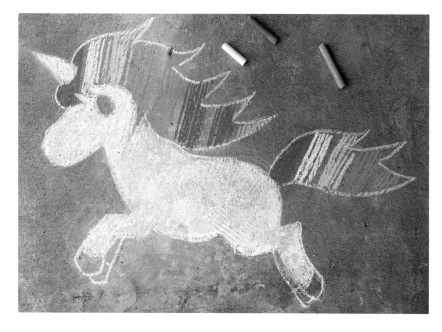

10. Now we're going to mix the colors. Start in the red area and add a couple yellow lines in it. Put a couple yellow lines where the light green is, and a couple green lines where the yellow is, and so on. These lines shouldn't cover most of the color, but should blend at the edges.

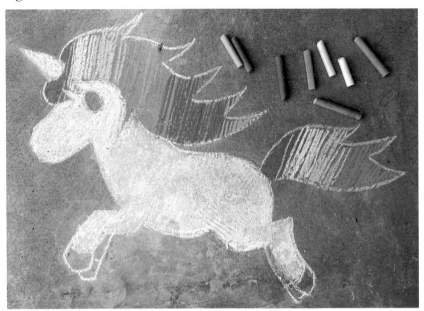

11. Smudge the colors. Change fingers or wipe them with a sponge before smudging very different colors.

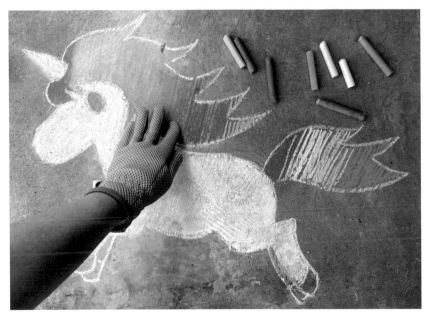

12. Smudge all the way across the mane and tail.

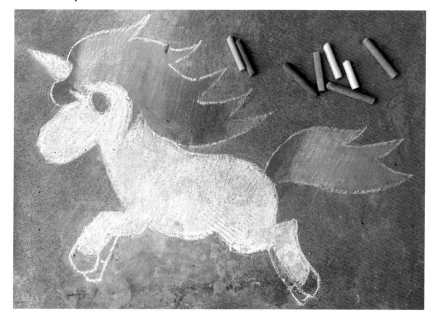

13. Color the eyes and hooves blue.

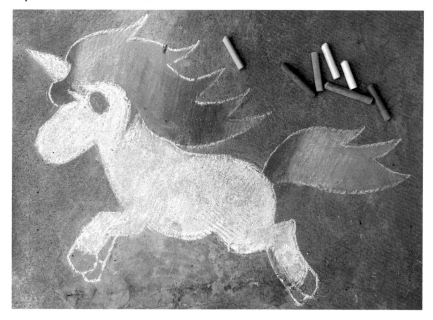

14. Smudge the eyes and hooves.

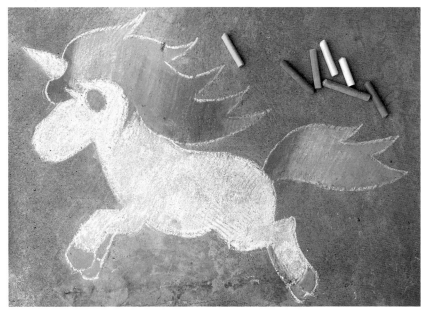

15. Outline the horn with black chalk, and add lines across the inside of the horn.

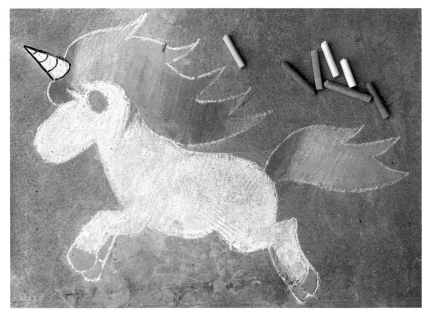

16. Outline the eye and put the pupil in.

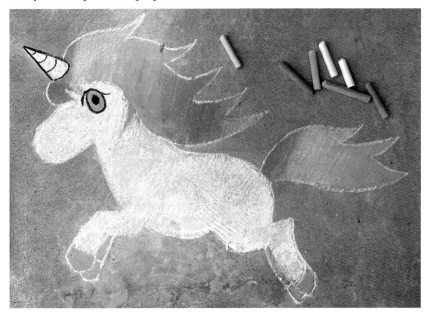

17. Begin to outline the mane.

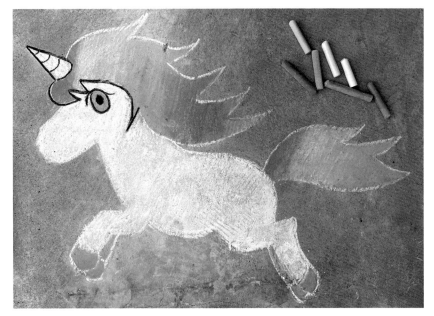

18. Finish outlining the mane.

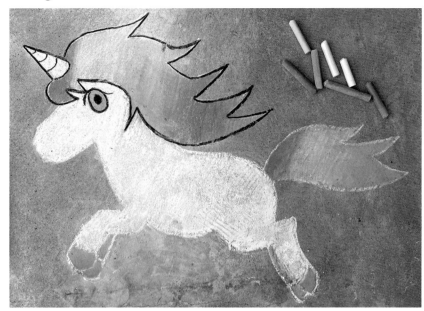

19. Outline the tail.

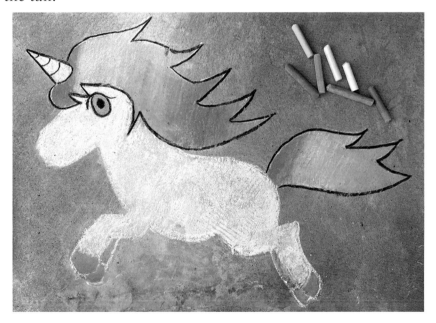

20. When you outline the face, also give the unicorn a small, curved smile. A smaller, thinner curve also gives the unicorn a nose.

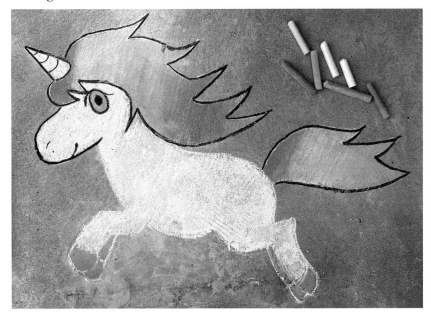

21. Outline the rest of the body. Now you can also color in the back legs. Color these gray to show their shadow and make them stand apart from the front legs.

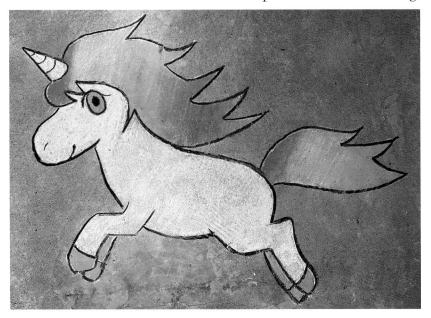

22. Your unicorn is complete and ready to bring some magic!

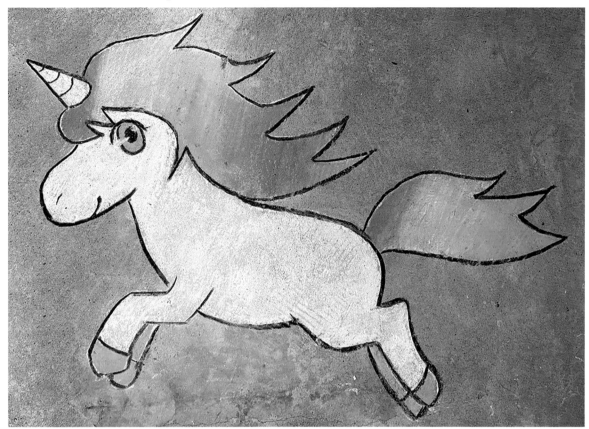

MONSTER

This is not a scary monster, but an adorable one, the kind of little manga monster who befriends kids and goes on adventures with them! As a reference, the drawing you see here is about twenty-two inches wide and sixteen inches high, but yours can be whatever size you want.

1. Start with a sketch on paper.

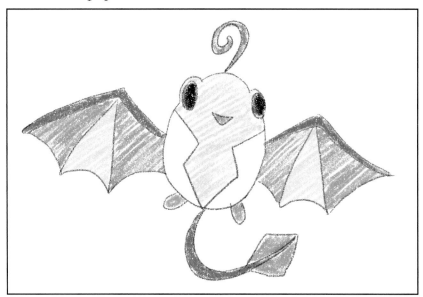

2. Draw a rough sketch to get the proportions right. It has an egg-shaped body, two wide wings, little oval feet, a kite-like tail, and a spiral over its head.

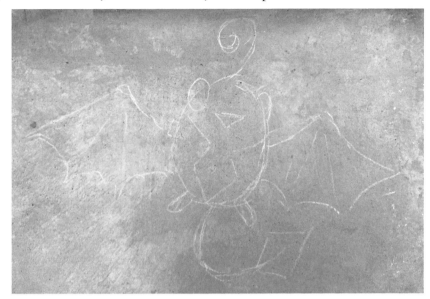

3. Outline the egg-shaped body and bumps for the bulging eyes.

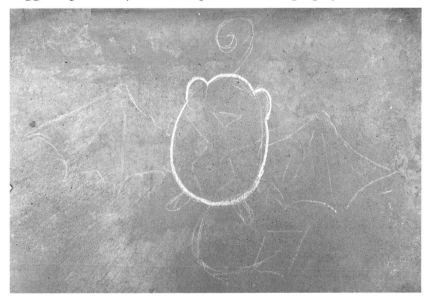

4. Add the actual eyes. They are oval-shaped. Then add a triangle for a smiling mouth.

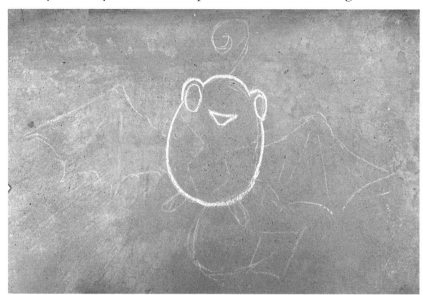

5. Add a design to the monster's belly. Add a curl on top of its head for an antenna.

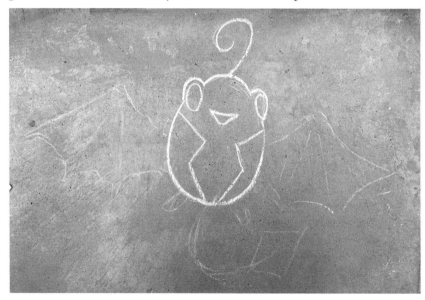

6. Draw two thinner ovals for feet.

7. Draw a bat-like wing. The top forms like a long triangle. The bottom has three curves.

8. Do the same for the other wing.

9. Go back to the top of the wings. Add another top of a triangle below the top of the wings.

10. Go to the peak of the second triangle. Draw lines down to touch the bottom of the wings.

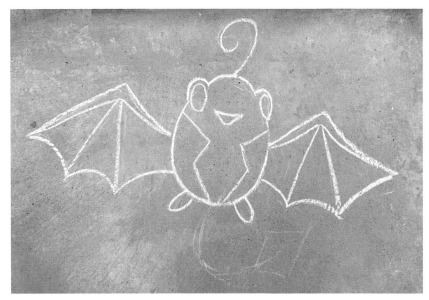

11. Add its tail, which loops to the side.

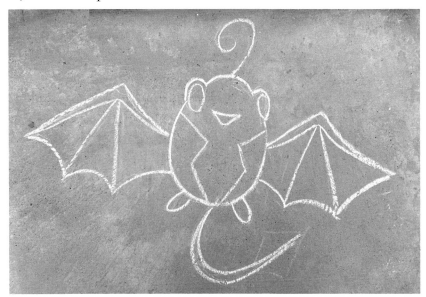

12. We're going to draw a kite-shape at the end of the tail. This also looks like two triangles back-to-back.

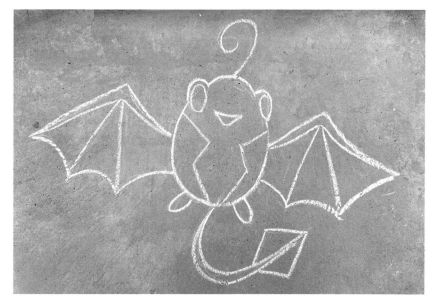

13. Fill in the center of its body with white chalk.

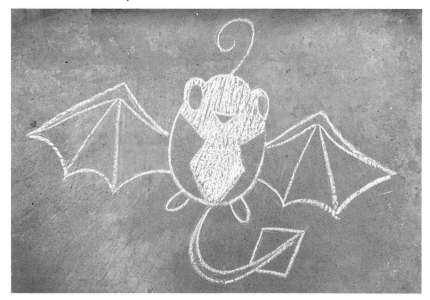

14. Fill in the same area with yellow chalk. Because white is lighter than yellow, it's important you do the white chalk first.

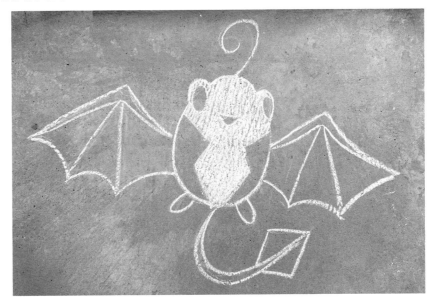

15. Smudge the white and yellow chalk so they mix.

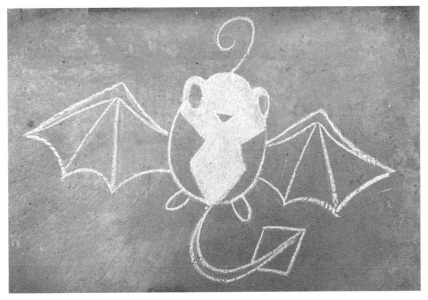

16. Fill out the rest of the main body with white chalk.

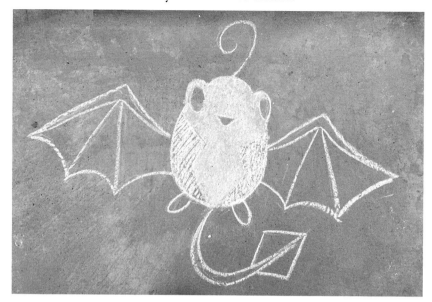

17. Color the tops of the wings and part of the tail blue. You might want to do a blue outline first before you color them in to keep yourself from coloring too far.

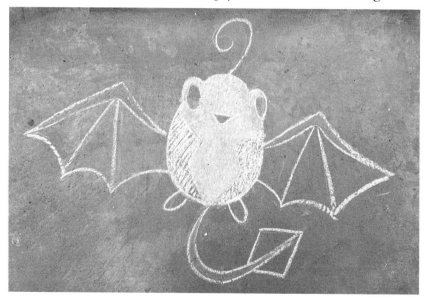

18. Draw lines of black chalk through the blue. Because blue is lighter than black, it's important you do the blue chalk first.

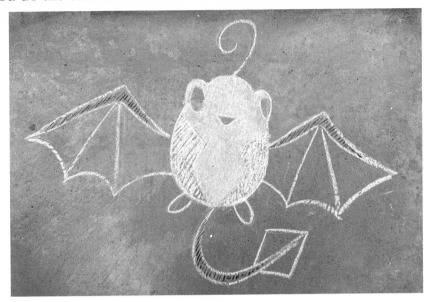

19. Color the center of the wings yellow. You might want to outline with the yellow chalk first so you don't color too far.

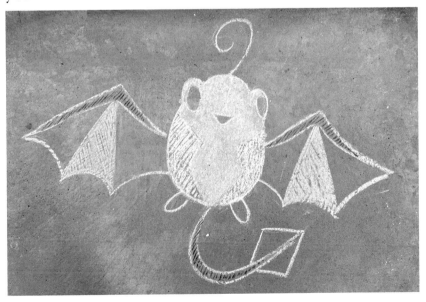

20. Color the rest of the wings, the kite-part of the tail, and the feet blue. You might want to outline with the blue chalk first.

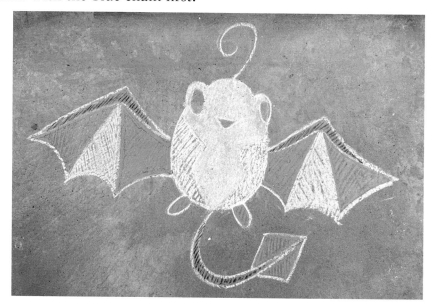

21. Outline the bulging eyes with brown chalk, then color the rest of the eyes brown.

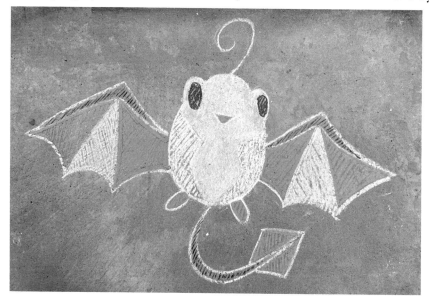

22. Smudge the white area first, being careful not to touch the other areas.

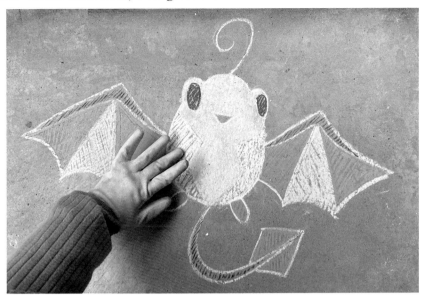

23. Add a bit of white chalk if anything looks thin after smudging.

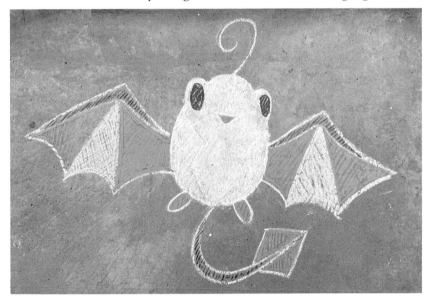

24. Smudge the yellow areas, being careful not to touch the other parts.

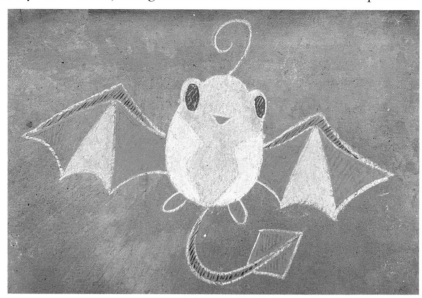

25. Smudge the main blue parts.

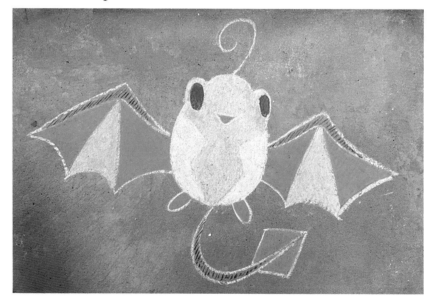

26. Smudge the blue and black chalk. This way it looks a little different from the rest of the blue by mixing colors, but it still blends well. Also put a blue spiral over the head for an antenna.

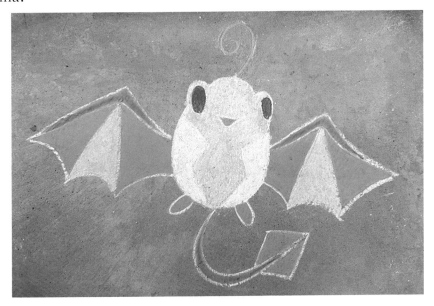

27. Use the black chalk for the eyes and mouth.

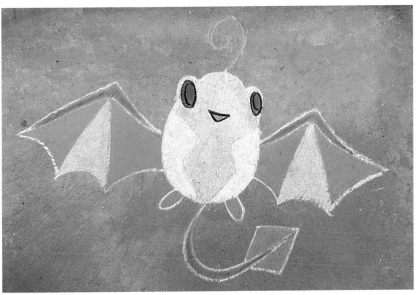

28. Outline the body with black chalk, using thick black lines.

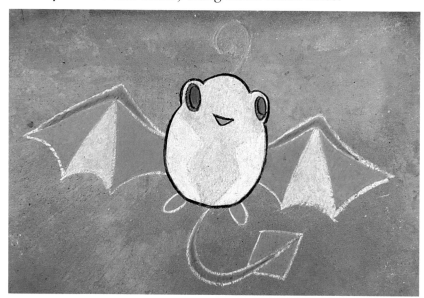

29. Use the black chalk to make thick lines between the white part of the body and the yellow-and-white mixed part of the body.

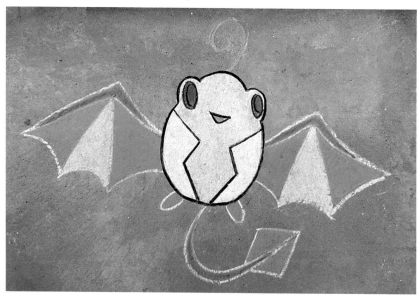

30. Begin outlining the wings with black chalk. The outside of the wings will have thicker lines than the inside.

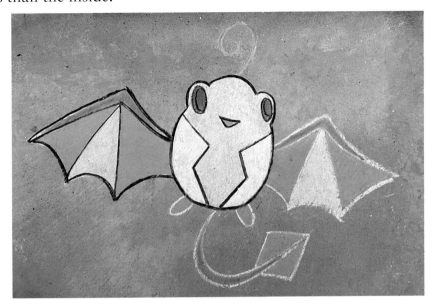

31. Outline its feet and the other wing.

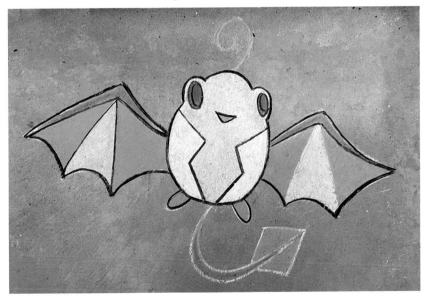

32. Outline the tail with thick black chalk.

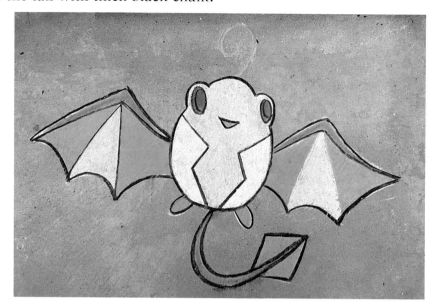

33. Add big, black pupils in the brown eyes. Do a line of black around the blue antenna. Outline the inside of the other wing with black chalk.

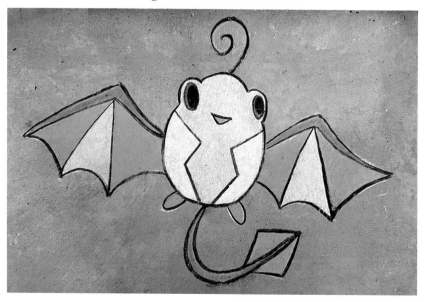

34. Add another black line around the antenna.

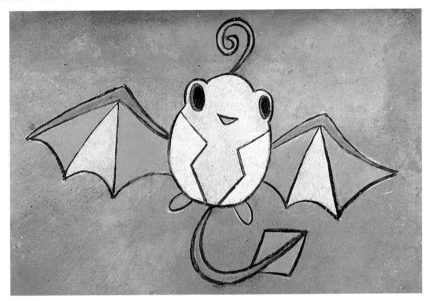

35. Put some white at the corners of the eye for a shiny look. Your monster is complete!

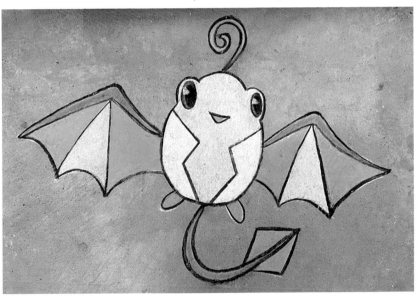

DINOSAUR

Sixty-five million years ago the Tyrannosaurus Rex (a.k.a. T. rex) roamed the earth, and today we can make a manga-style version of it out of chalk. We don't know exactly what a real T. rex looked like while it was alive, but since this is manga, it's okay to be creative! As a reference, the drawing you see here is about thirty-eight inches wide and twenty-five and one-half inches high, but yours can be whatever size you want.

1. Start with a basic sketch of the T. rex on paper. It has a big head compared to its body because of the manga style.

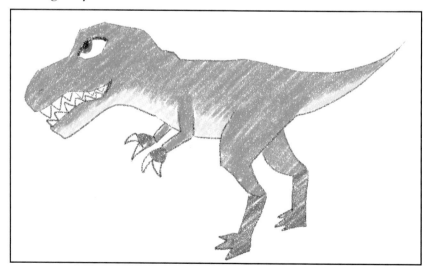

2. Draw a basic outline of the T. rex. It doesn't have to be perfect, but this will help you with your proportions.

3. Draw the eye. The pupil is looking up.

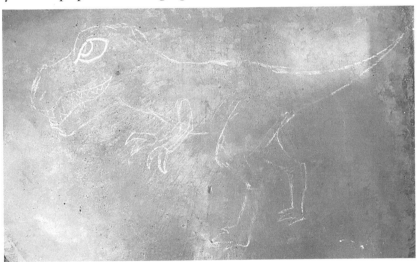

4. Work on the head. The T. rex will have a powerful jaw. Watch the little curves that make the shape of the head. Also put in a slightly curved line for the nose.

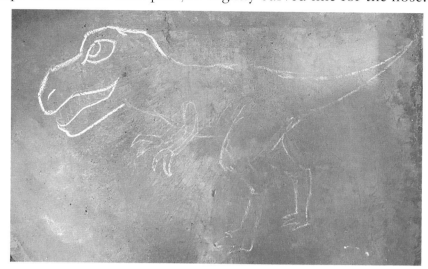

5. What big teeth! Start with the top of the mouth and draw upside down triangles.

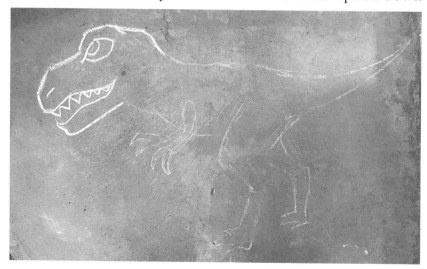

6. Finish the mouth by drawing more triangles for teeth.

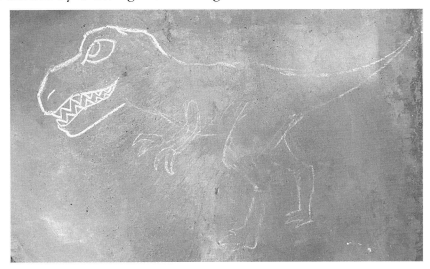

7. Draw the body. Because this is manga, which is exaggerated, the middle of the body is about the same length as the head. Its tail is a long, thin triangle pointing up.

8. Draw one of the arms. The arm is short and has two clawed fingers. Put in a little line to show where the claw starts. Also put a line at the wrist.

9. Do the same for the other arm.

10. Start outlining the back leg. Watch how it curves out.

11. Finish the leg. Put a line between the top of the leg and the lower half. It has three pronged toes.

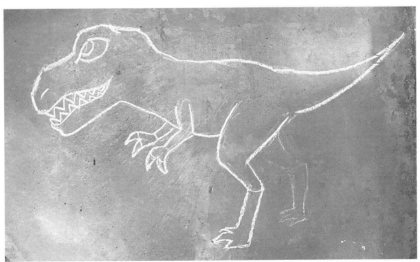

12. Begin outlining the back leg.

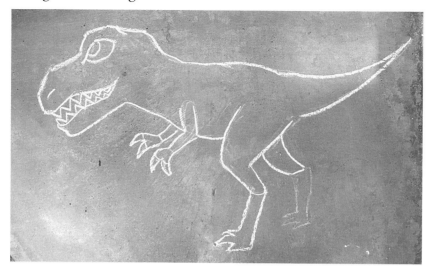

13. Finish the leg, including the feet and toes.

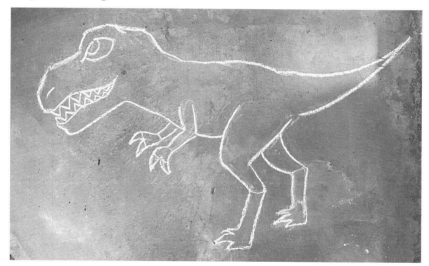

14. We're going to begin coloring it with green chalk. You might want to trace the green chalk around the white chalk first to make sure you don't color too far, as you can see here.

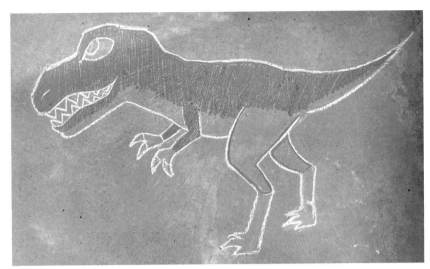

15. Finish coloring with the green chalk.

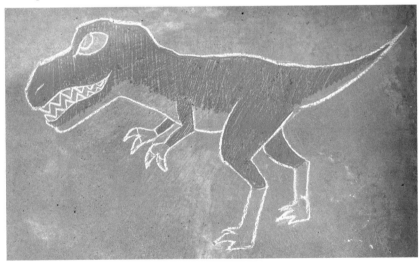

16. Take the yellow chalk and trace inside the white outline around the chin, abdomen, and tail.

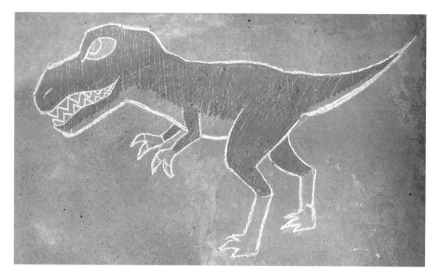

17. Fill in the yellow parts.

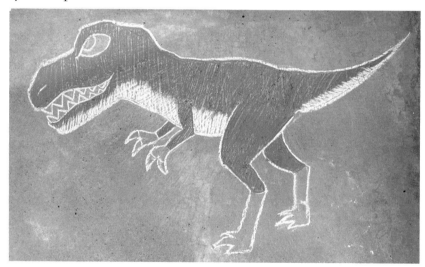

18. Color the teeth, eye, and claws white. Then take the brown chalk and color the pupil, the hands, the legs, and the feet.

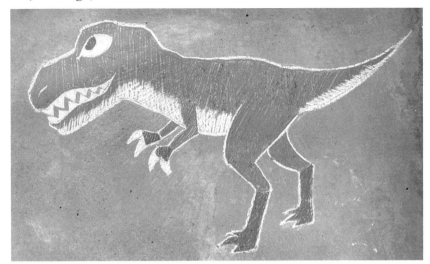

19. Go back to the brown places. Trace their outline with black and insert black lines through them.

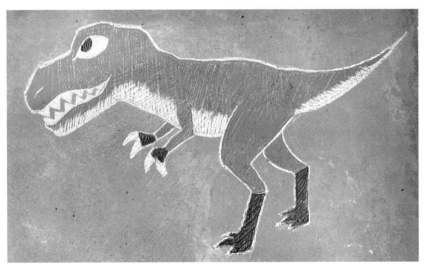

20. It's time to begin smudging! You want to start with the softer colors, so do yellow and then green.

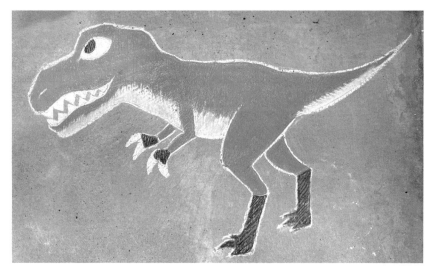

21. Sometimes we try not to blend the colors on different parts of the character. But this time we want to smudge the green and the yellow together where they touch, so the colors look like a smooth transition. That's why it was okay to do the green before the yellow, because we're going to have them touch anyway. Then smudge the brown and black parts.

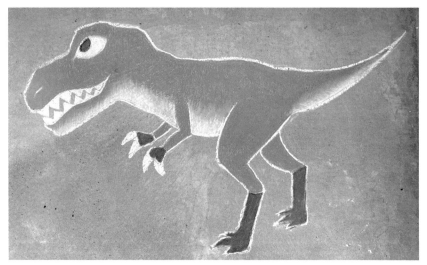

22. Outline the eye with black chalk, and also the pupil. Make the chalk thicker on the upper eyelid for a stronger look.

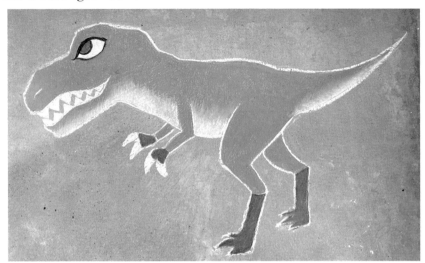

23. Put some white on the eye for a shiny look.

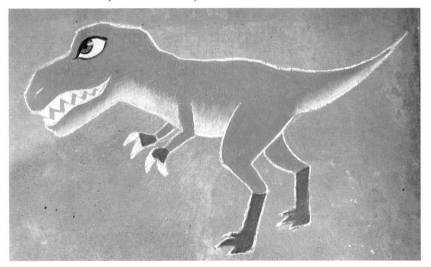

24. Start to outline the rest of the body.

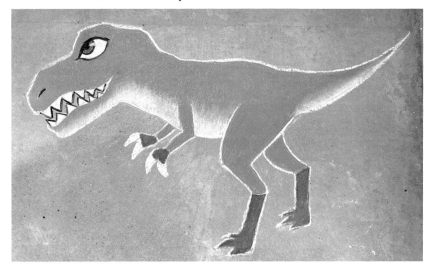

25. Outline the head, following the curves. Do this in smaller lines instead of all one movement.

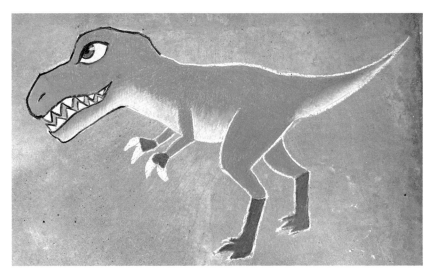

26. Outline the back and tail, watching for the curves.

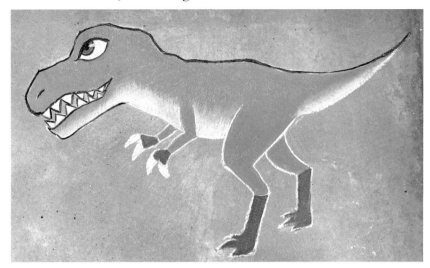

27. Outline the bottom of the tail.

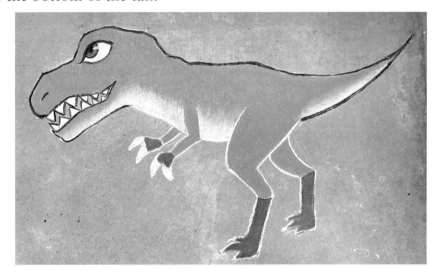

28. Outline the arms and belly.

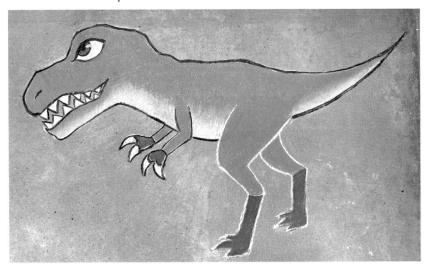

29. Outline the back legs.

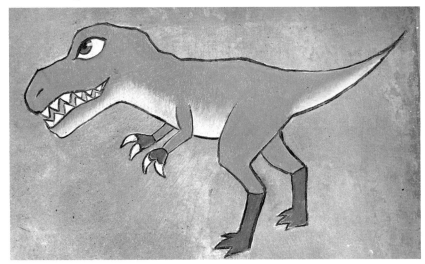

30. We're going to add some white lines to give the T. rex a shiny look. Put a white line over the nose, two white lines over the head, white lines on the arms and legs, and white lines on the back and tail. Your T. rex is done!

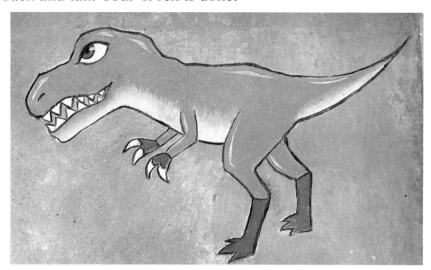

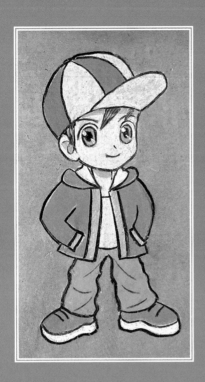

CHIBI BOY AND GIRL

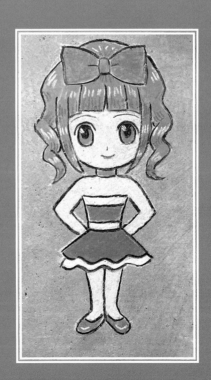

CHIBI BOY

Chibi means "short" in Japanese and is also an art style in manga and anime where the characters are exaggerated and extra small. They have big heads and tiny bodies. We're going to start with a chibi boy and then move on to a chibi girl. As a reference, the drawing you see here is about ten inches wide and twenty inches high, but yours can be whatever size you want.

1. Start with a sketch on paper.

2. Begin with a general sketch for proportions. It doesn't have to be perfect.

3. Start with the bill of his hat. Use thick lines so you can see what you're doing over the original sketch.

4. Draw the hat over his head.

5. Put some lines through the hat.

6. Draw the eyes. He has a curved line just above his eyes, then another curved line above that for his eyebrows. There are circles in the top corner of his eyes. He has a small, slanted line for a nose and a curved line for a smile.

7. A few triangles show his hair peeking out from under his hat.

8. Draw his face. On the right, the line of his face goes straight until just below his eye, then curves into a pointed chin. On the other side of his head, draw half an egg shape for his ear, and put a circle and loop for the inside of the ear.

9. Draw his neck and the top of his collar. The collar is two long triangles.

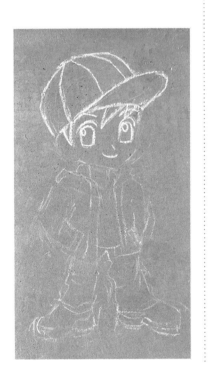

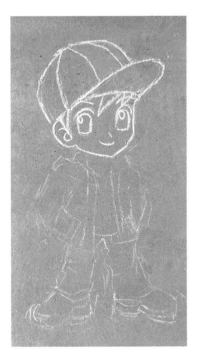

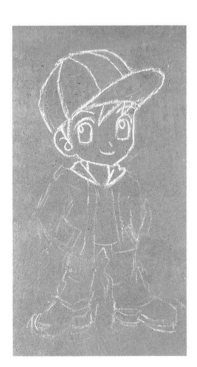

10. Draw the top of his jacket around the collar.

11. Draw his arms and add little rectangles for his cuffs. His hands are in his pockets, so you don't have to worry about them.

12. Draw in the rest of his jacket. He has two lines going down on each side of the center.

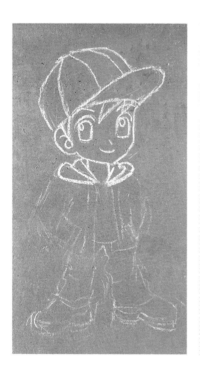

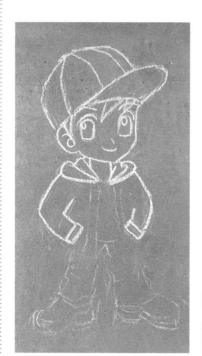

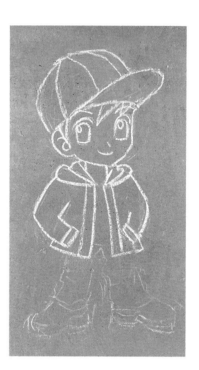

13. Draw curved lines for his shirt between the opening of the jacket. Give him slightly baggy pants with a little bit of curving to your lines.

14. Draw his shoes. The insides of the shoes will curve a little.

15. Put two lines on the top of his shoes for shoelaces.

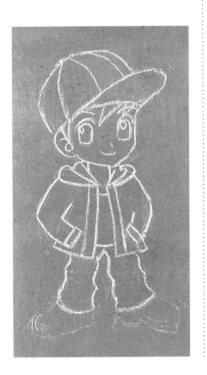

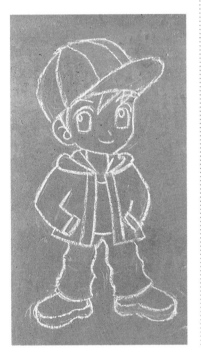

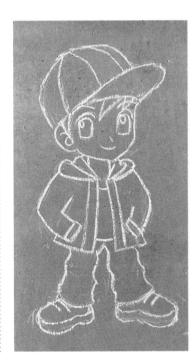

16. It's time to begin coloring. Start with his skin.

17. The heels of his shoes and clothing by his neck are white. Color his hat alternating yellow and red. You might want to trace the yellow and red inside the white chalk outline to make sure you don't color too far. In this example, we used brown for his hair and blue for his eyes.

18. Then put some white lines on the inside of his jacket. After this you can move on to darker colors. His shirt is yellow. Color the main part of his jacket blue. Go back to the inside of the jacket where you put white lines. Put alternating light blue lines next to the white.

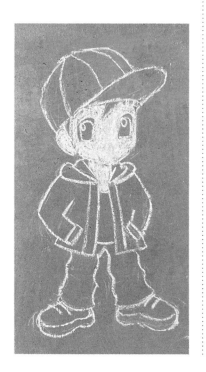

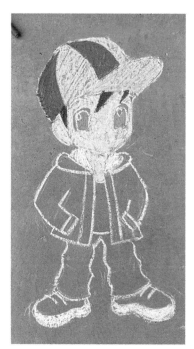

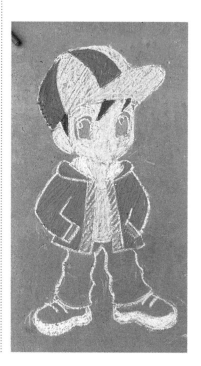

19. Color his pants green and the top of his shoes the same blue as his jacket.

20. Smudge the different areas. Use different fingers or clean them before smudging different colors.

21. Here's how he looks when he's all smudged.

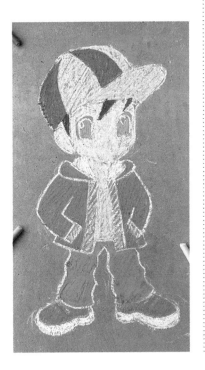

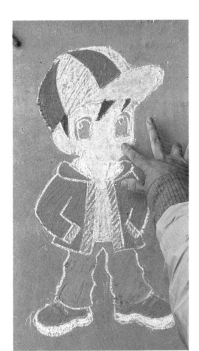

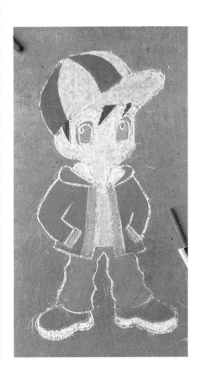

22. After you're done smudging, put white in his eyes. Because it's a small area, you don't need to smudge.

23. Start to outline his hat using black chalk.

24. Outline his hair.

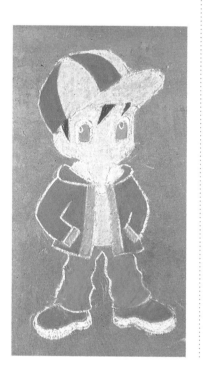

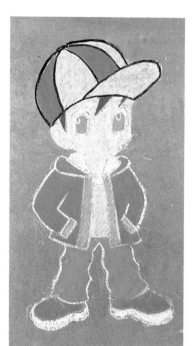

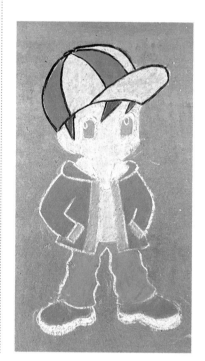

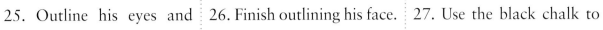

25. Outline his eyes and eyebrow.

26. Finish outlining his face.

27. Use the black chalk to color in his pupils.

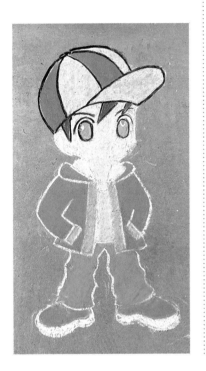 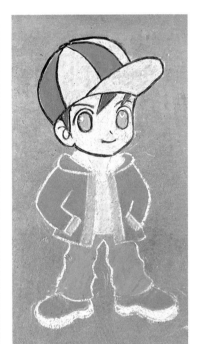 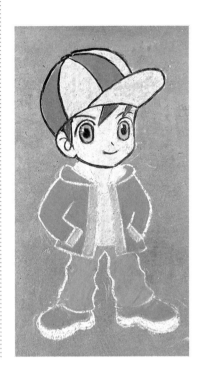

28. Put white circles more clearly over the pupil to give his eyes a shiny look.

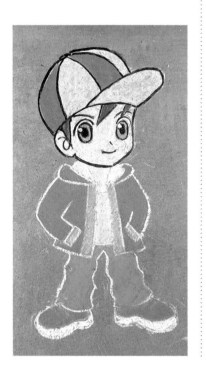

29. Outline the top of his clothing.

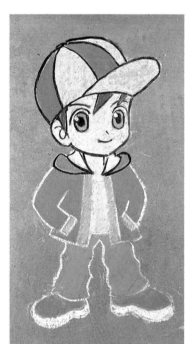

30. Finish outlining the clothes on the top part of his body.

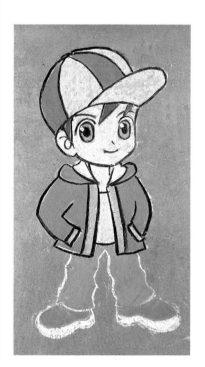

31. Outline his pants.

32. Outline his shoes. Don't forget the shoelaces on top.

33. Put a few black streaks in his hair.

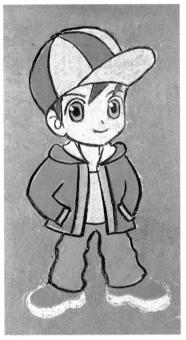

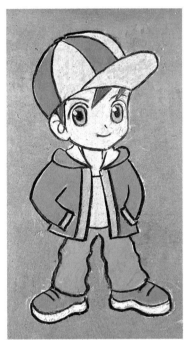

34. Now put a few white streaks in his hair for a shiny look.

35. Take a color slightly darker than his skin color and color in shadows on his forehead, under his chin, and in his ear. Add a few lines on his pants for creases.

36. Add a bit more white to his eyes for a shinier look, and erase any extra lines around him. Your drawing is done!

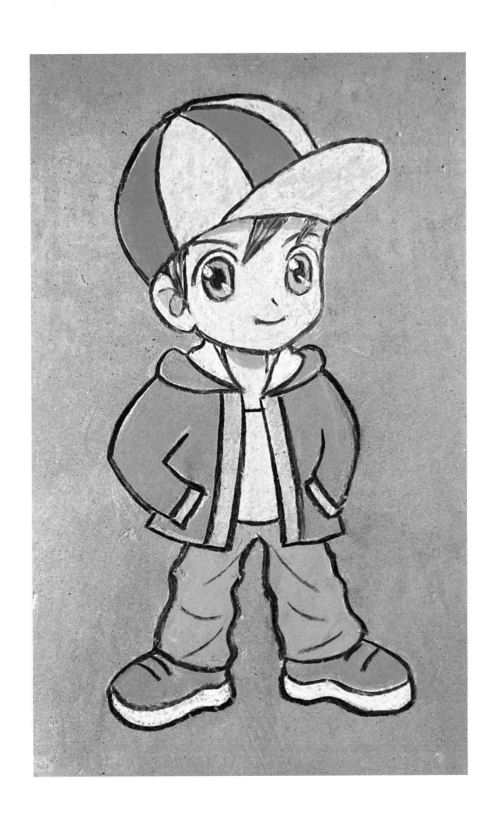

CHIBI GIRL

Now we're going to draw a chibi girl. She has the same proportions as the chibi boy, with a head much bigger than her body. As a reference, the drawing you see here is about nine inches wide and twenty inches high, but yours can be whatever size you want.

1. You might want to start by drawing the character on paper first to help guide you.

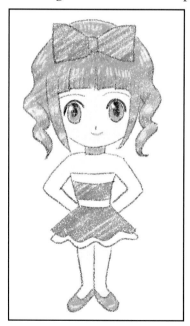

2. Begin with a general sketch for proportions. It doesn't have to be perfect. Remember the head is much bigger compared to the body.

3. Start with her hair ribbon. There will be a small rectangle in the middle, then the two sides of the ribbon. Each side of the ribbon starts out smaller and grows wider. On each far side it dips in a little. Put some lines in the bow to show creases. Draw thickly so you can see it over the sketch.

4. Draw two big eyes with eyebrows on top. The nose is between and just below the eyes, and it's barely more than a dot. The mouth is a curve.

5. Draw rectangles for her bangs. Draw the long hair that frames her face.

6. Draw the rest of her hair. Draw with curving motions to get the spirals of her curls.

7. Finish her face. She has a small neck.

8. Draw her arms. Her hands are tucked behind her, so you don't need to worry about those.

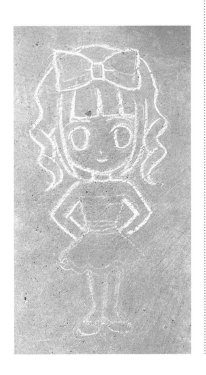

9. Draw her waist, and lines going across it for her clothes.

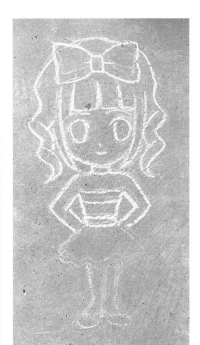

10. Draw her skirt. Two straight lines on each side, then waving curves down the middle.

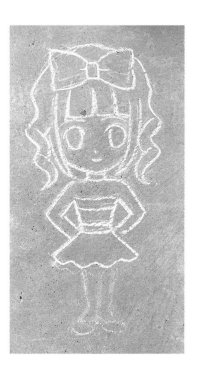

11. Draw more waving curves for another level of her dress.

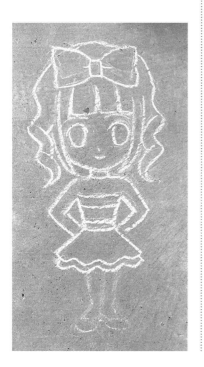

12. Draw her leg, and her little shoe.

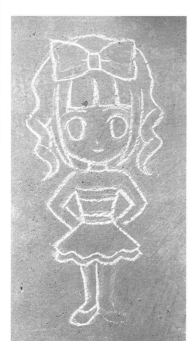

13. Draw her other leg and shoe.

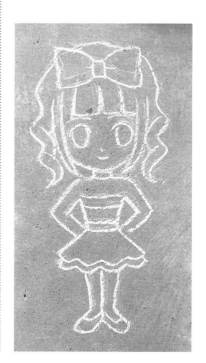

14. Now it's time to color! Begin with her skin.

15. Color the bottom of her eyes pink. Above that, color her eyes purple.

16. Take the same pink you used for her eyes and trace the inside of her hair.

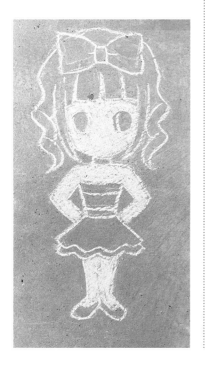

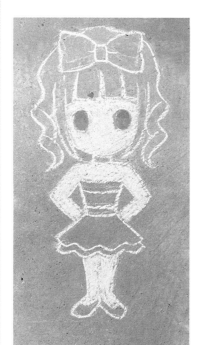

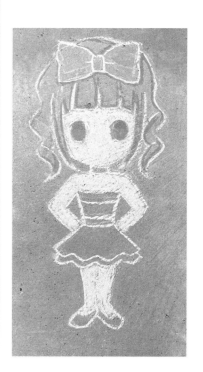

17. Color in the rest of her hair. Put the same pink on her neck for a pink choker, and also color in her shoes. Color the top of her dress, the middle of her dress, and the very bottom of her dress white. After you're done with the white, take the same purple chalk you used for her eyes and color the ribbon and rest of her dress.

18. Smudge the areas. You might want to use a different finger for each color, or clean your fingers or gloves when moving from one color to the next.

19. Here she is smudged.

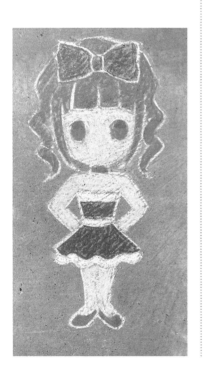

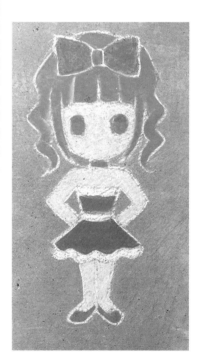

20. After you've smudged all the other colors, smudge the pink and purple together in the eye for a nice blending effect.

21. Outline the ribbon with black, and remember to go over the two small crease lines.

22. Give her two thin black eyebrows.

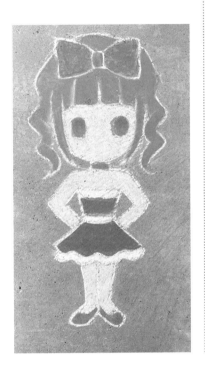

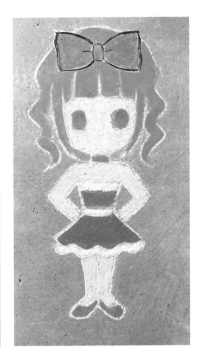

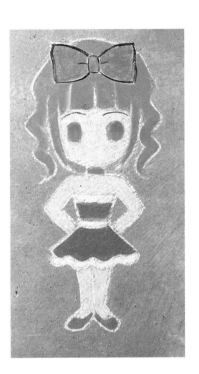

23. Outline her eyes.

24. Put in black pupils. Also put some black above the pupils.

25. Use the black for her small nose and mouth.

26. Begin outlining her hair.

27. Continue to outline her hair, including the curls.

28. Outline the bottom of her face and her neck.

29. Finish outlining her choker.

30. Outline her shoulders and arms.

31. Outline the top of her dress.

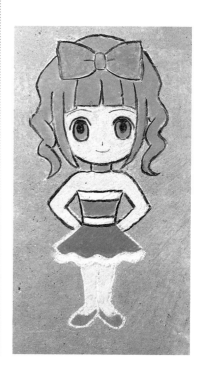

32. Finish outlining her dress.

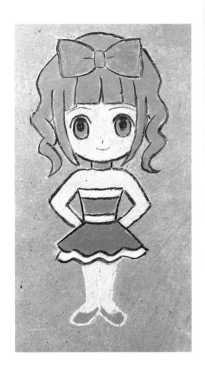

33. Outline her leg and shoe.

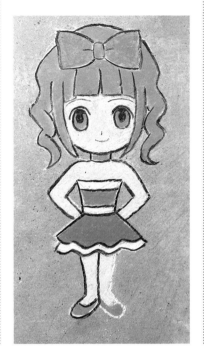

34. Outline her other leg and shoe.

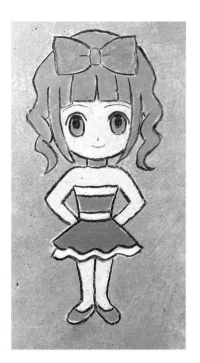

35. Draw several purple lines in her bangs and around her ribbon.

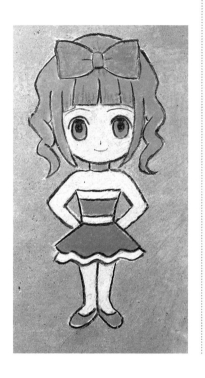

36. Continue to draw these purple lines in her hair.

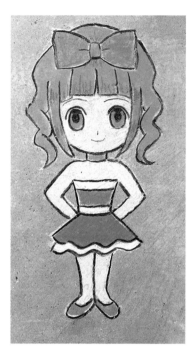

37. Draw more purple lines in her hair, this time where the hair curls. Also follow the lines of the curls.

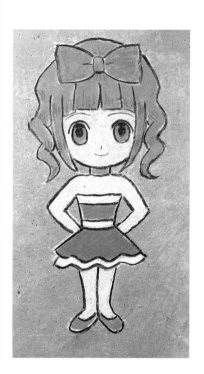

38. Put some white in her eyes to give them a shiny look.

39. Put a few white lines in her hair as well for a shiny look.

40. Add more shiny white lines around the purple lines in her hair.

41. Add white lines to the curls, also making them curl.

42. Put in a few more white lines to finish the shiny look to her hair.

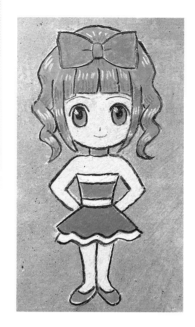

43. Put white curved lines on her shoes to make them look shiny.

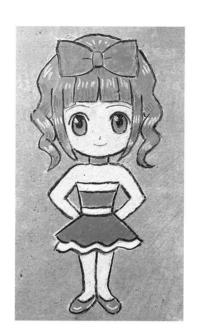

44. Add a little pink to her mouth, and your chibi girl is complete!

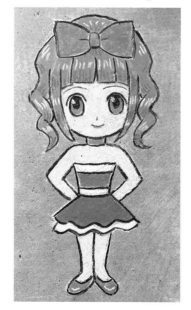

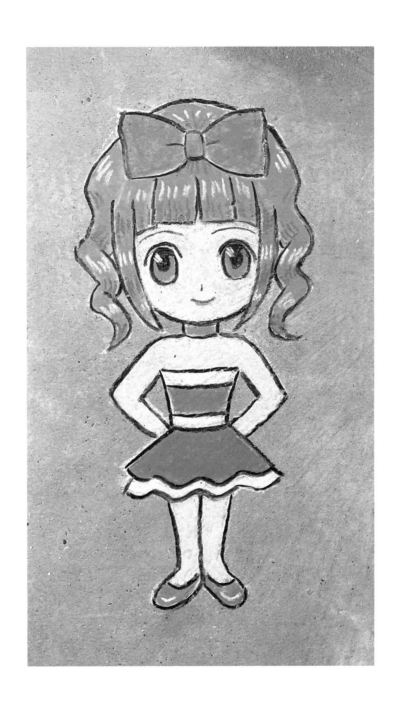

MANGA PEOPLE

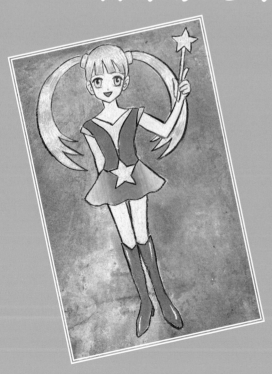

MAGICAL GIRL

The magical girl is a common character type in shojo, or girls' manga. Her magic powers help her save the day, and she wields a wand. As a reference, the drawing you see here is about twenty-four inches wide and thirty-six inches high, but yours can be whatever size you want.

1. You might want to sketch her out first on paper to help you draw on the pavement.

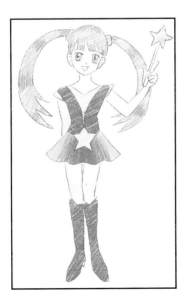

2. Begin with a rough sketch using white chalk. It doesn't have to be perfect. This will help you balance the figure. She has two long twintails, a flared skirt, and a long body.

3. Let's begin on the upper half of her body. Draw stronger lines so you don't confuse it with the initial sketch. She has big eyes with curved lines for eyebrows. Her nose is a dot, and her mouth is an upside down triangle. Her ears are to the sides of her eyes and a little bigger than her eyes. Her chin is pointed.

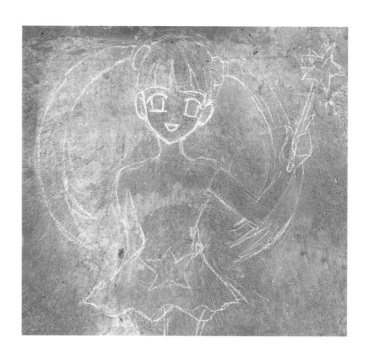

4. Her bangs are thick rectangles. The top of her head is rounded. Put two curves next to her head for where her hair is tied.

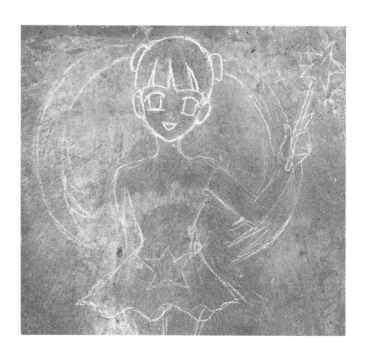

5. Draw out her long, curved hair. Each twintail ends with three prongs.

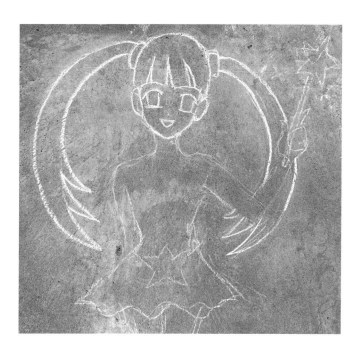

6. Draw her neck and the beginning of her shoulders.

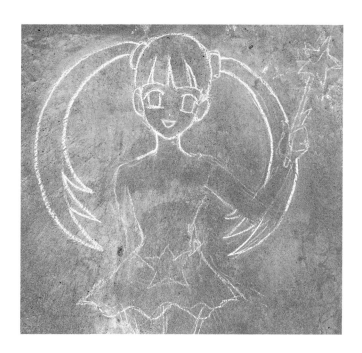

7. Draw a Y-shape down the front of her dress.

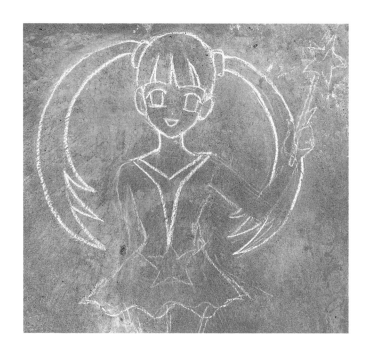

8. Draw her narrow shoulders. She has two long triangles for the sleeves on her dress.

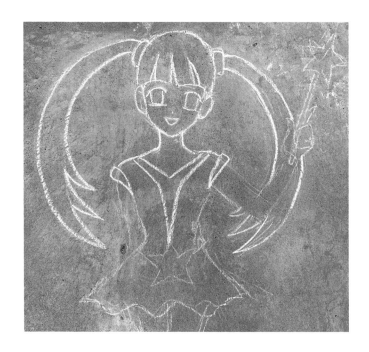

9. Next, draw her arms. One is tucked behind her and the other holds her wand.

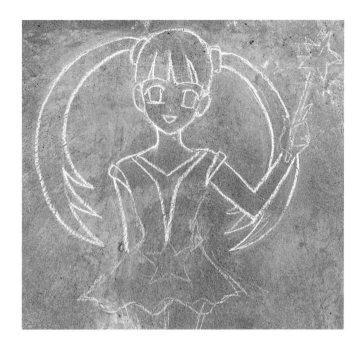

10. Next, draw her hand. Hands can be tricky to draw. There is an outward curve that turns into her thumb. Three fingers hold the wand. Her index finger is pointing up.

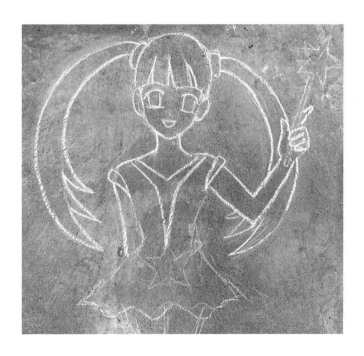

11. Her wand is a long stick with a five-pointed star on top. Also put a star on her outfit, under the Y-shape.

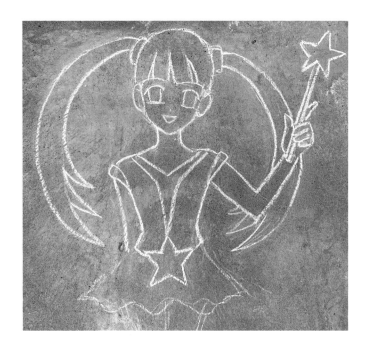

12. Even though we haven't drawn her bottom half, we're going to go ahead and start coloring. Her hair, the Y-shape on her dress, and both stars are yellow. You might want to trace the yellow inside the white lines so you don't go over them when coloring. It's helpful to color all the parts that are the same color at the same time.

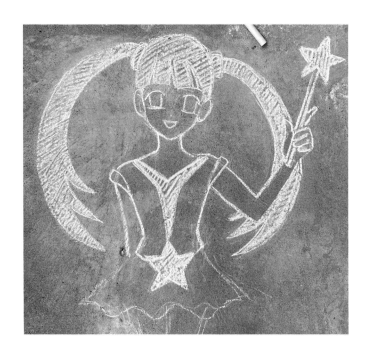

13. Color her wand white. Since it's a slim wand, you can just color it white fully on the inside and you don't need to smudge. Then color her skin, followed by her green sleeves and red dress. For the skin, sleeves, and dress, you might want to trace inside the outline with each color you're using.

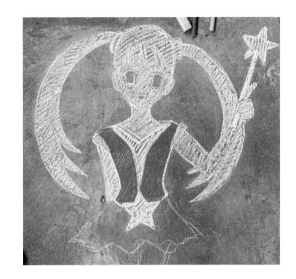

14. It's time to start smudging! Begin with the yellow because it's a light color.

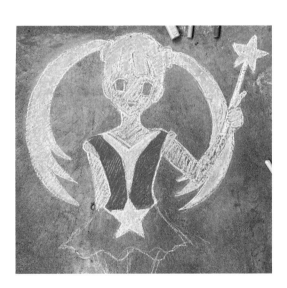

15. Smudge the skin, then the green, then the red. It's generally best to smudge lighter colors first and then move on to darker colors.

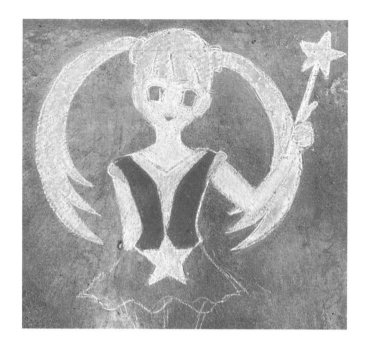

16. Color her eyes completely green. Her triangle mouth is red.

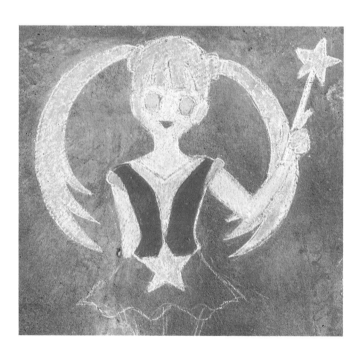

17. Take the orange chalk (or a light brown chalk) and put some lines through her hair to make it pop more. The lines go on her bangs, the top of her head, and every so often along her twintails.

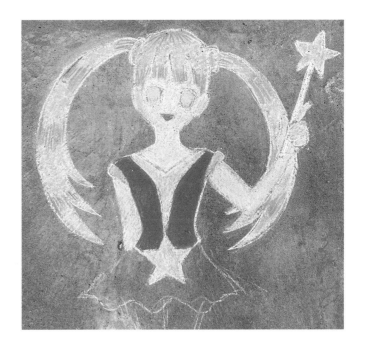

18. Begin outlining her hair with black. If you're right-handed, start on the left. If you're left-handed, do the opposite.

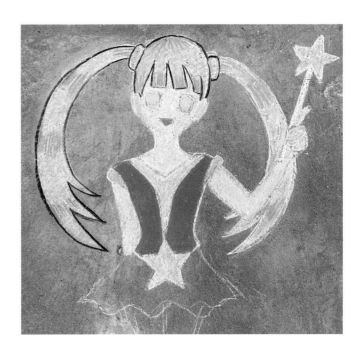

19. Outline her face with black. It's probably better to do line by line and connect them rather than trying to trace it all at once.

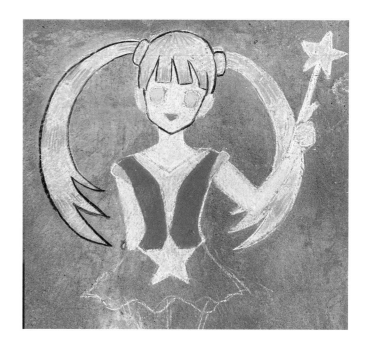

20. Outline her ears.

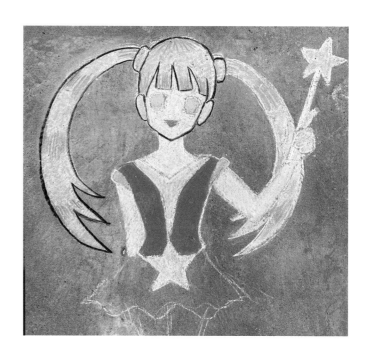

21. Put a circle and a curve inside her ear. They look kind of like the number 6, but one will be flipped backward.

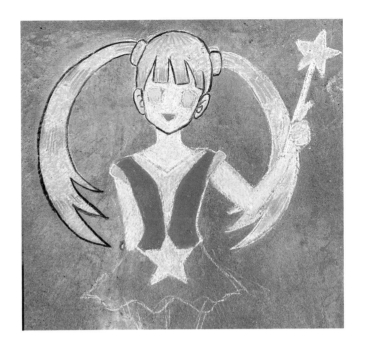

22. Draw in her eyebrows. Give her green eyes more of an oval shape, and put two curved lines above and below each eye. The curved line over her green eye is bigger than the curved line under her eye.

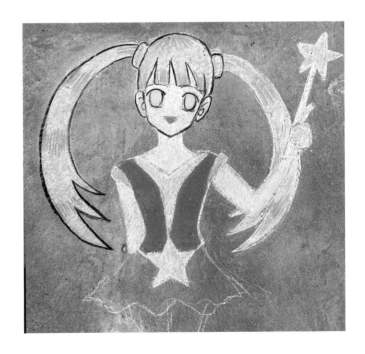

23. Outline her mouth.

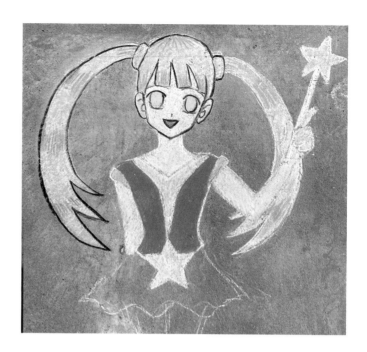

24. Outline her neck and the start of her shoulders.

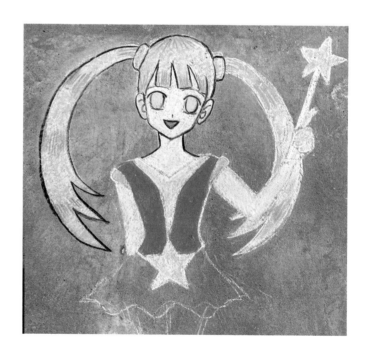

25. Returning to her eyes, use the black chalk to draw in big pupils looking up. Also make the curved lines above her eyes much thicker.

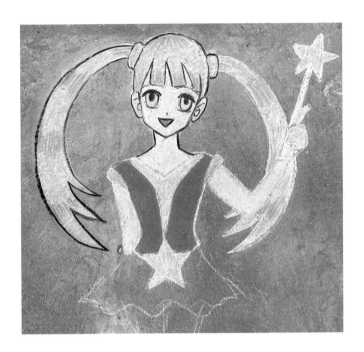

26. Finish her eyes by putting in little white lines to make a shiny look.

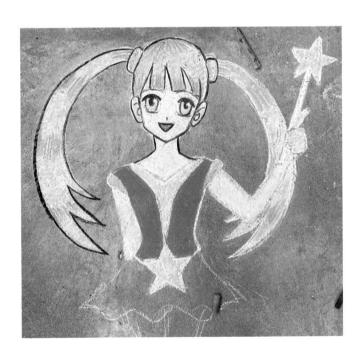

27. Outline her other twintail. It's easier to combine shorter lines than to try to trace it all at once.

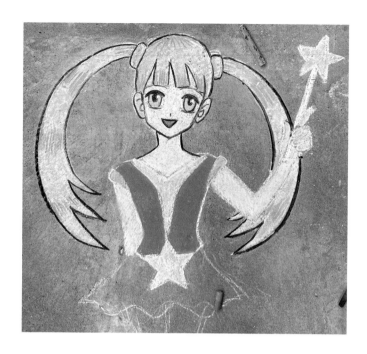

28. Work on outlining her wand. Since white and yellow are light colors, be careful you don't get them smeared when you do this.

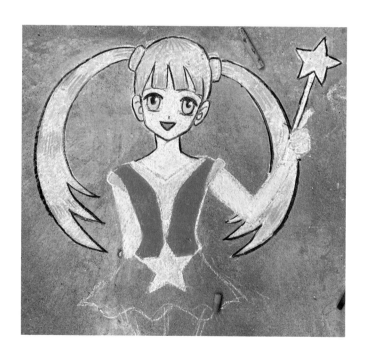

29. Finish outlining her wand, and move on to her hand.

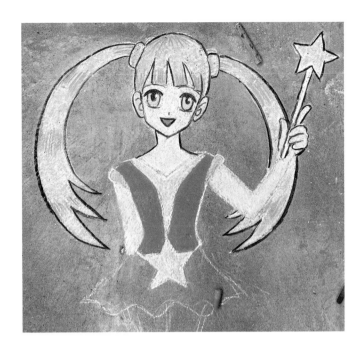

30. Outline her arms, and the top part of her clothing, but leave the star for now. If you outline the star now, it might smear the skirt area when you work on the skirt.

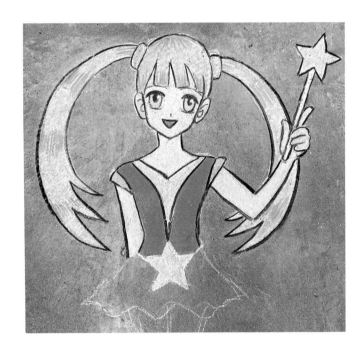

31. Let's work on the lower half of her body. First, take the white chalk and draw the skirt more clearly. It has four waves on the bottom.

32. Draw her legs down to her knees.

33. Her boots go up to her knees. The boots end with pointed toes. You put a little curve for a heel on her right foot (our left).

34. Color both edges of her skirt with light green, and color the middle of the skirt dark green. Have some space between the colors.

35. Draw two thick dark green lines in each light green area, then draw two light green lines next to the dark green lines.

36. Color her skin, then her red boots. You might want to trace inside the outline first to make sure you don't color too far.

37. Smudge the skin first because it's a lighter color.

38. Smudge the skirt so that the greens blend.

39. Outline the skirt and then the star.

40. Outline her legs.

41. Smudge her boots.

42. Outline her boots.

43. Add some white lines at the top and bottom of her boots to give them a shiny look.

44. For a final touch, also add some white lines to her hair for a shiny look.

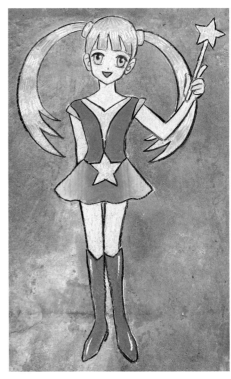

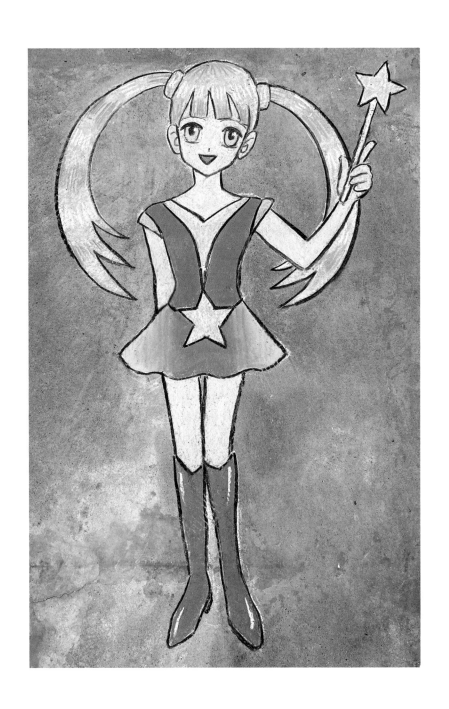

NINJA

Ninja are specially trained warriors from feudal Japan. Plenty of legends—and manga!—have been written about their daring escapades. This ninja is holding *shuriken*, sometimes called throwing stars or ninja stars. As a reference, the drawing you see here is about twenty inches wide and thirty-six inches high, but yours can be whatever size you want.

1. You might want to start with a sketch on paper to help guide you when you draw with chalk.

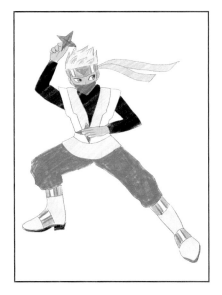

2. Do a rough sketch for proportions. It doesn't have to be perfect. This is going to be a big sketch, so doing this also helps ensure that you have enough room for it.

3. Like we did with the magical girl, let's start by working on the top half of the body and then move to drawing the lower half. That's because both of these are such big drawings. His thumb is long next to the shuriken. His four fingers are curled so they look like stubs. As you fill in the details, make sure you use thicker lines than you did for your sketch.

4. Draw his right arm (your left). It's bent at the elbow.

5. Draw his headband, and an upside-down triangle in it. Give him spiky hair.

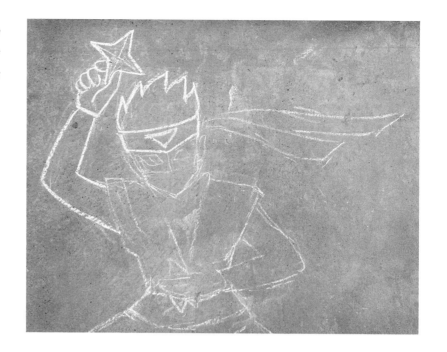

6. The bottom part of his face is covered by a mask. Draw his eyes between the mask and headband. He is looking to the side. Draw his ears on the sides of his face, level to his eyes. His headband is tied around his head, and the back is waving in the wind. Since it's not easy to get the waves in one stroke, try doing shorter lines and connecting them. If you make a mistake, it's easy to erase.

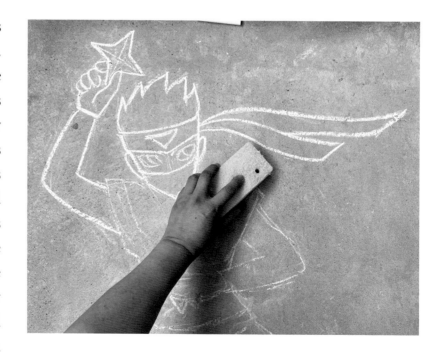

7. Move on to the top of his clothing.

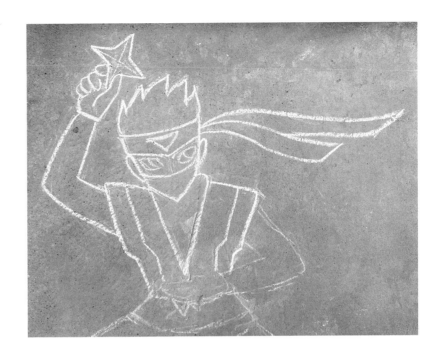

8. Draw his other arm. There's a line at the wrist to show where his sleeve ends. His hand is pressed out flat, with four long fingers. We can't see his thumb. He is holding another shuriken.

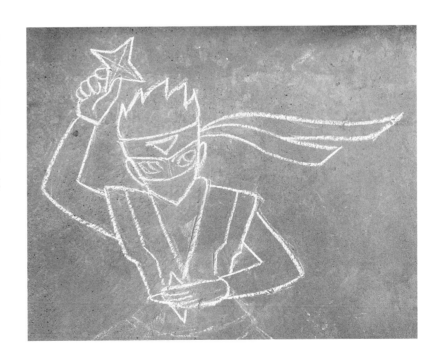

9. Draw in more at his waist.

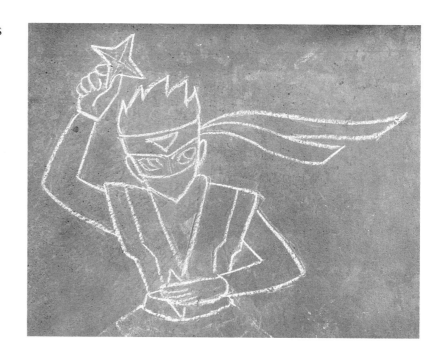

10. Color and smudge his skin.

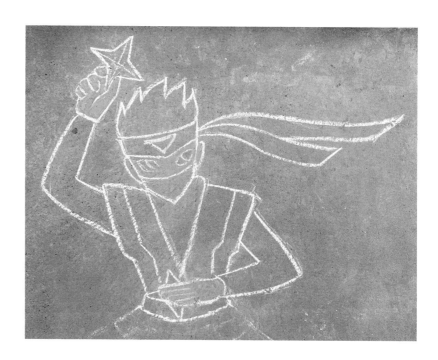

11. Color part of his eyes white, leaving space for his pupils. Then color the outside of his shirt white. Inside that, color yellow. The shuriken are dark gray because they're traditionally made of iron or steel. His mask is also gray. The triangle in his headband is blue. The waving parts of the headband are green. You might want to trace inside the outlines with each color first to make sure you don't go too far.

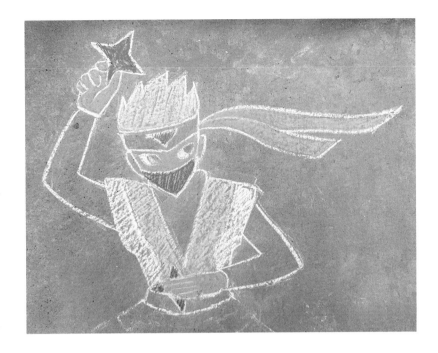

12. Smudge the colors. Use different fingers for different colors, or clean your finger before moving on to another color.

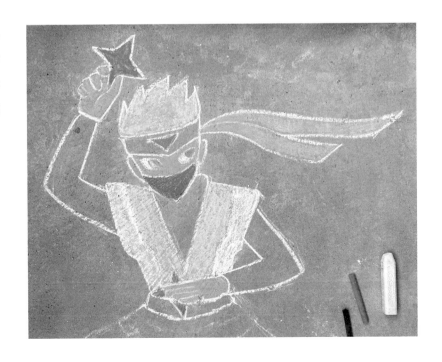

13. Outline his right hand, arm, and shuriken.

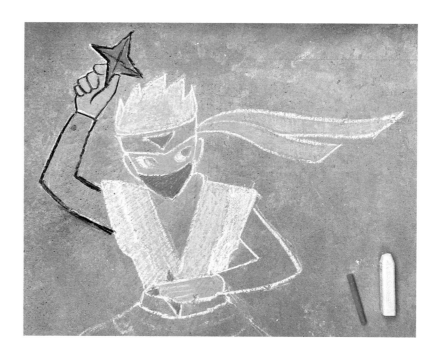

14. Outline his headband and hair.

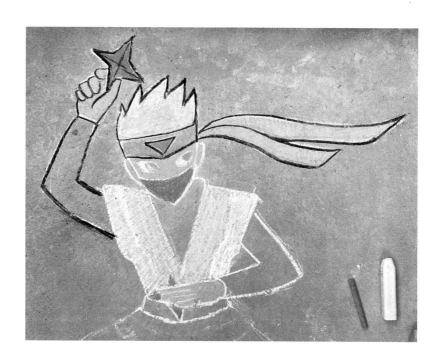

15. Outline his face, ears, and mask.

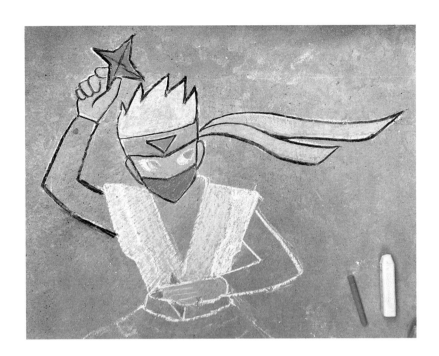

16. Go back to his eyes. Outline them, and put pupils in the eye corners. Leave some of the pavement there to make it look as if he has gray irises. Then outline the gray part you left.

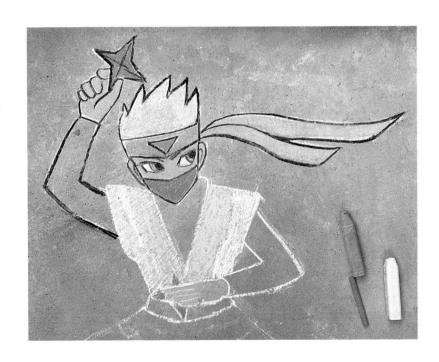

17. Outline more of his clothing.

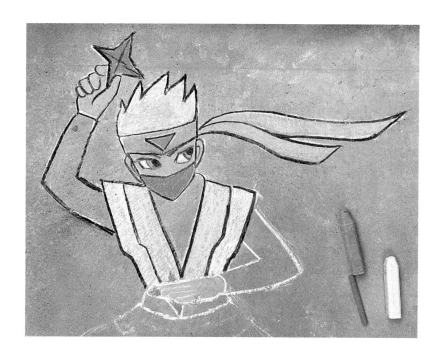

18. To make his headband look as if it's made out of metal, we're going to start by putting three vertical gray lines on each side.

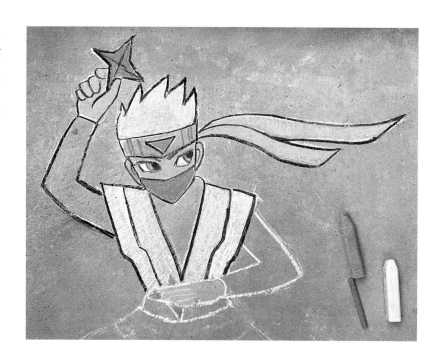

19. Put a white line on each side, between two of the gray lines. This makes the headband look metallic and shiny.

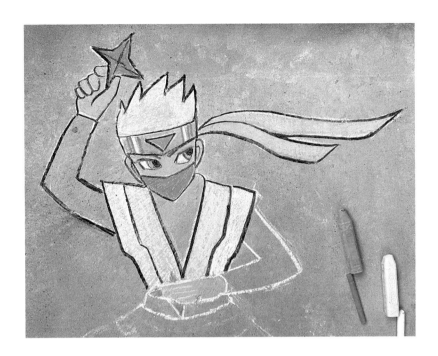

20. With the gray chalk, make flame shapes and little waves in his hair so it will look more realistic.

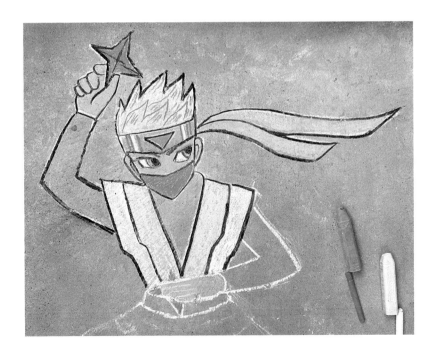

21. Outline his other arm, hand, and shuriken.

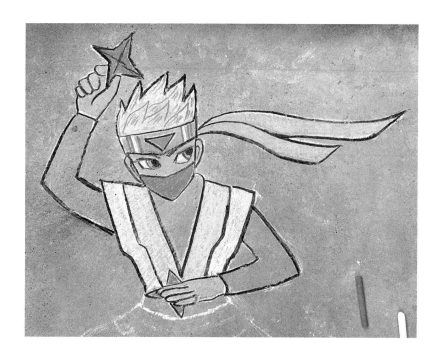

22. Color the rest of the clothing on the top half of him black. Save this for last because black is easy to stain into other areas if you color black earlier.

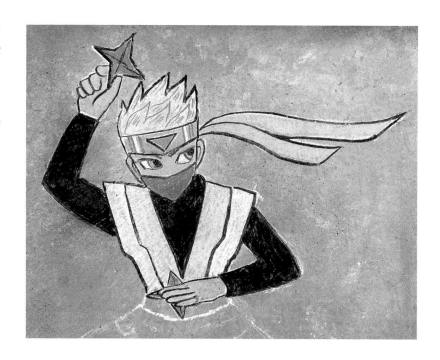

23. Add some white lines over his eyes to give them a shiny look.

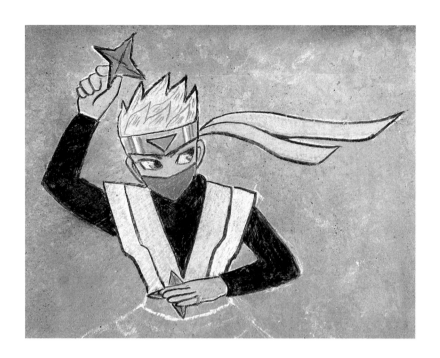

24. Now we can move on to the lower half of his body. Start by drawing the bottom of his shirt to look like a skirt.

25. Draw his pants. They will have some bumps along the edges to show creases. One leg looks much shorter than the other one because of how he's standing.

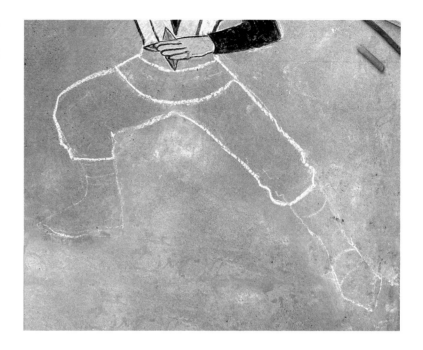

26. Draw his boots. There are three lines going through each shoe, and his right foot (your left) will also have a heel drawn in under the shoe.

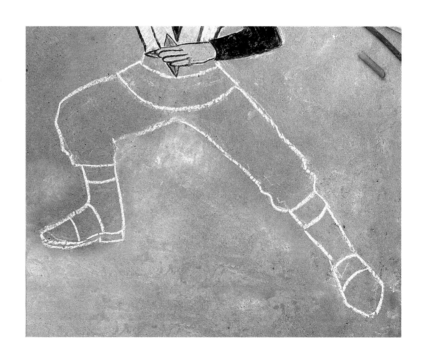

27. Color the bottom of his shirt and parts of his boots yellow. It makes sense to color all those parts at the same time because they're the same color. You might want to trace inside the outline with yellow first to make sure you don't color too far.

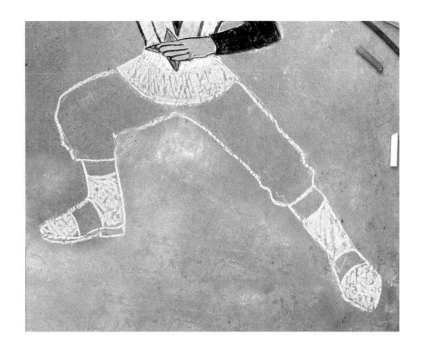

28. Color his pants dark gray.

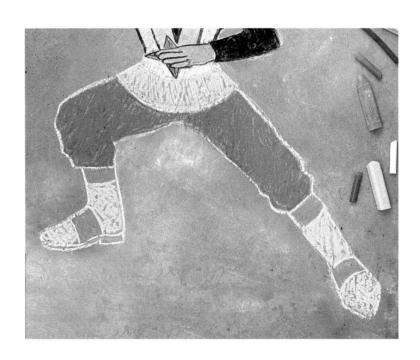

29. Smudge his pants, the white parts and the yellow parts.

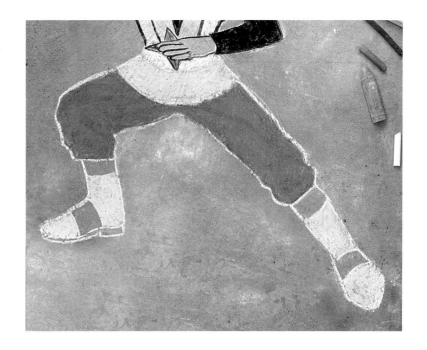

30. Outline the bottom of his shirt and his pants with black chalk.

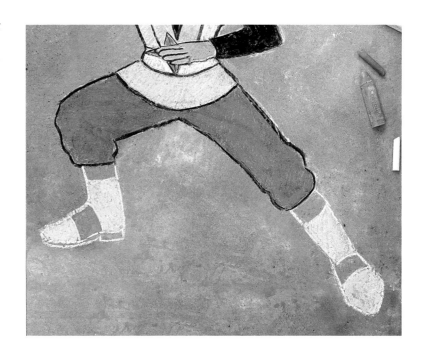

31. Outline his boots with black chalk, and color in his heel.

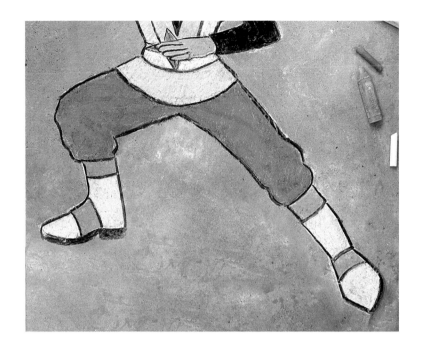

32. Draw a few lines in his pants to show creases.

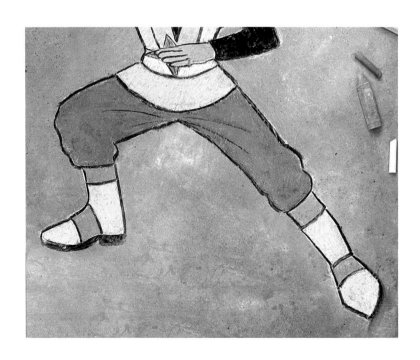

33. We haven't colored in the other parts of his shoes, but they look gray from the pavement. To make them look shiny, put three gray lines on the part of the shoes that cover the middle of the foot.

34. To finish that shiny look, add a white line between two of the gray lines on each shoe.

35. We're going to do the same thing for the gray area higher up on his shoes. Start with three gray lines.

36. Now put a white line between two of the gray lines.

37. Add a little line for a nose if you want. Here is your finished ninja, ready for battle!

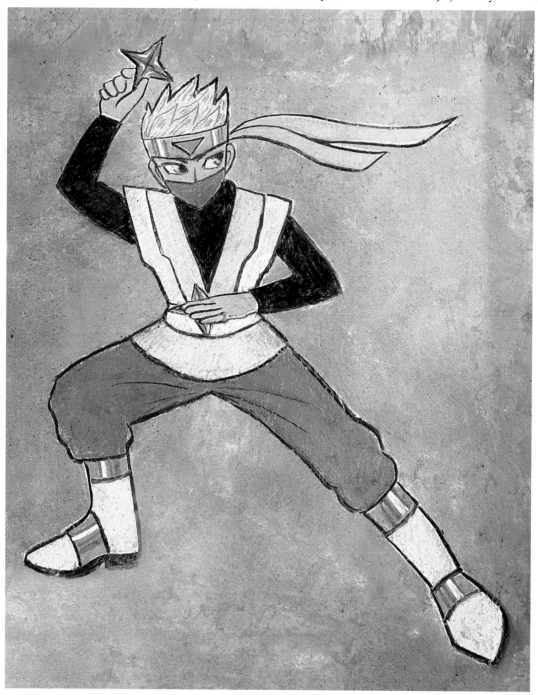

HARAJUKU GIRL

Harajuku is a district in Tokyo, and it's also a colorful and over-the-top fashion style. Since the colorful Harajuku style lends itself well to colored chalk, here is a girl wearing the very vibrant fashion. As a reference, the drawing you see here is about twenty-two inches wide and thirty-six inches high, but yours can be whatever size you want.

1. Since this is a more complex drawing, you might want to draw her out on paper first.

2. Start with a basic sketch with light white chalk. This is just to help you with proportions. She has wavy hair, a flared skirt, and a long body. She's holding an umbrella.

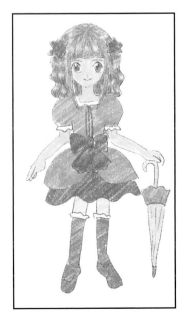

3. Give her big eyes and two lines for eye-brows. Her nose is a dot and her mouth is a small curved smile. As you draw over your basic sketch, use thicker lines.

4. She has rectangles for bangs, a pointed chin, a thin neck, and a rectangular collar.

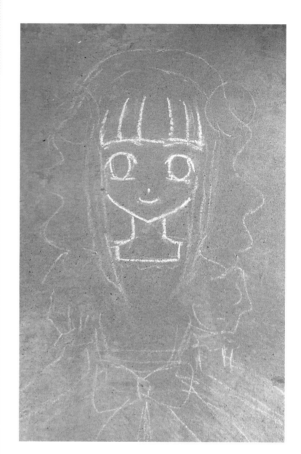

5. Add a triangle to the rose on the left side of her hair.

6. Put two other triangles next to it, forming a circle.

7. Place a loop over it. This is a petal.

8. Put in another loop for another petal.

9. Add another loop for another petal.

10. Put in another loop for another petal.

11. Do one more loop to finish off the rose.

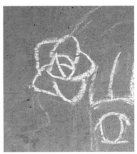

12. We're going to do the same thing for her second rose, but with the other side of her head. Start with a triangle.

13. Put in two more triangles to make a circle.

14. Put a loop over the circle for a petal.

15. Add another loop for another petal.

16. Put in another loop for another petal.

17. Add another loop for another petal.

18. Add one more loop to finish off the second rose.

19. With the roses done, draw the top of her head. She has a couple of lines on her head to show her hair movement.

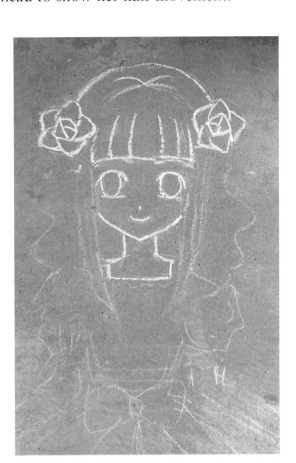

20. Give her two long, curved triangles for her hair at the sides of her face.

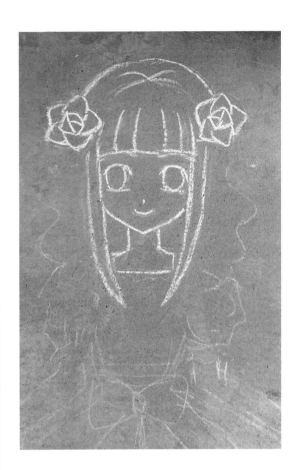

21. Put in the start of her wavy hair.

22. Put a couple of waves close to her neck to show hair in the back.

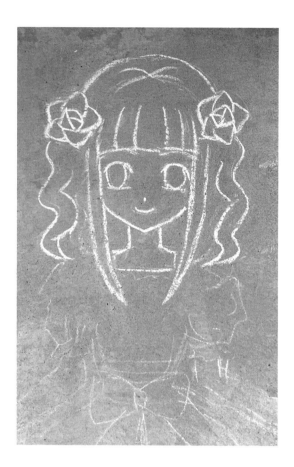

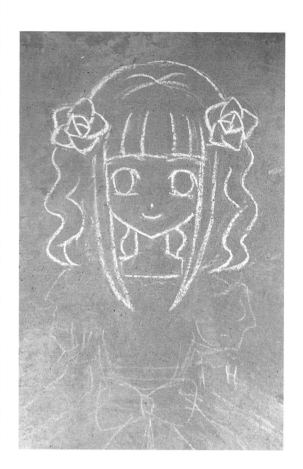

23. Put in more waves at each side of her head.

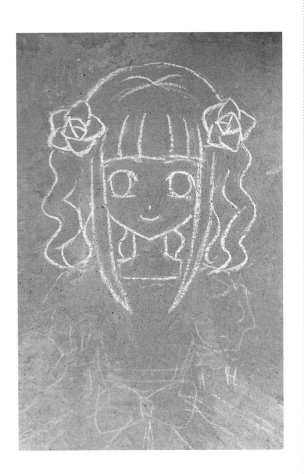

24. Give her a lacy collar.

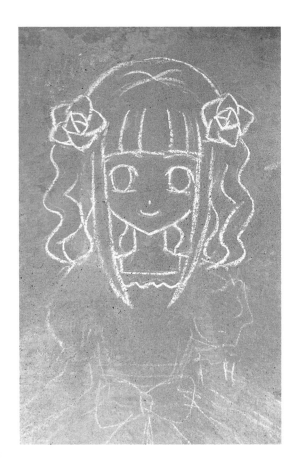

25. Give her puffy sleeves. Two curved lines in each sleeve show creases. Give her more lace below her sleeves.

26. Draw down to her waist.

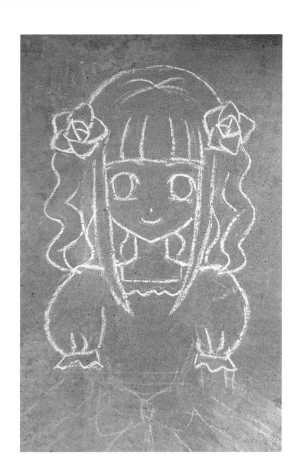

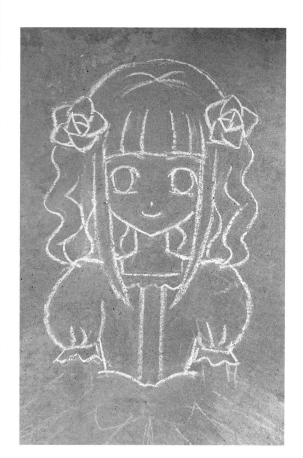

27. Since this is a big drawing, we'll start coloring the top part of her and draw the rest later. Begin by coloring her face and neck.

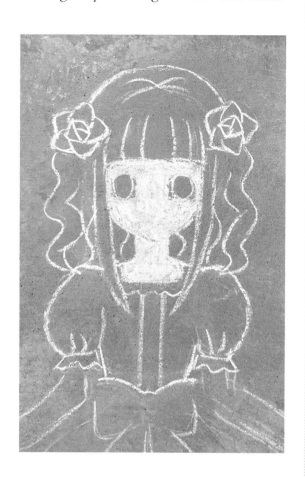

28. Trace the outlines of her hair with pink chalk.

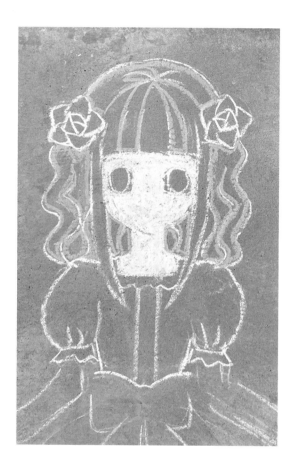

29. Color most of her hair pink, but leave some parts alone for now.

30. Color the remaining parts of her hair orange. You might want to trace the outline with orange first so you don't color too far. Continue tracing like that as you work on the Harajuku girl.

31. Color her rose and eyes red.

32. Smudge the colors. Use different fingers for different colors or wipe your finger with a sponge between colors.

33. Put some dark pink lines in her bangs and the top of her hair.

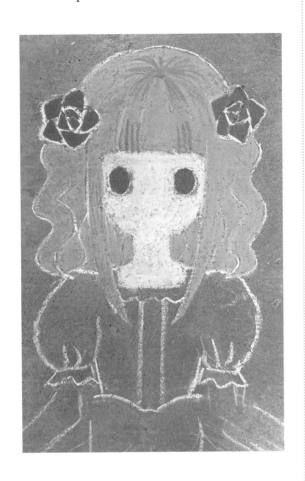

34. Add more dark pink lines in her hair.

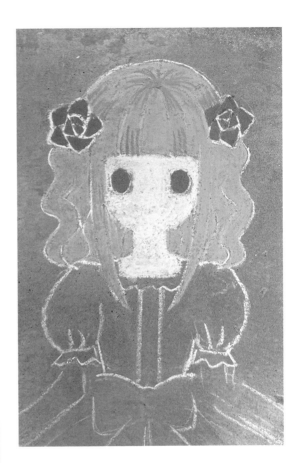

35. Start adding wavy dark pink lines in her curls. Watch how these lines move with the hair wherever you add them.

36. Add more dark pink lines.

37. Continue to add more dark pink lines.

38. Go to the hair on the other side of her head and draw in dark pink lines.

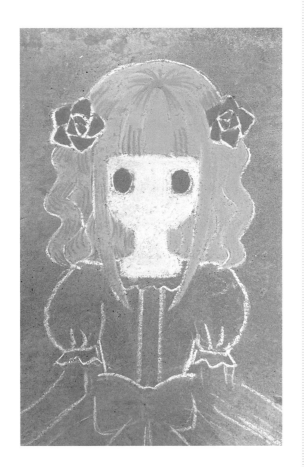

39. Add more dark pink lines.

40. Finish the dark pink lines in her hair.

41. Add some dark pink lines to her orange bangs.

42. Add more pink lines to her orange hair.

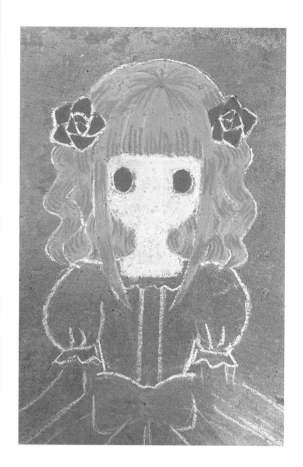

43. Add white lines to her hair for a shiny look. Don't put them in the same places you put the dark pink lines.

44. Add more white lines for shine throughout her hair. Have the lines move with the hair.

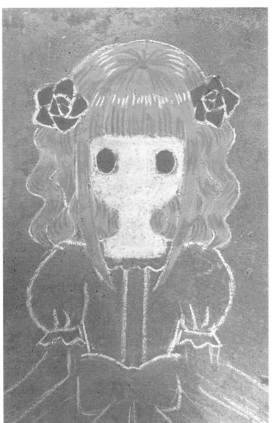

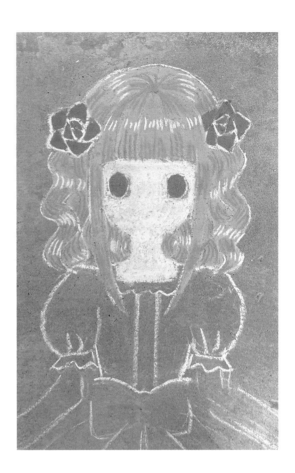

45. Begin outlining her hair and rose with black chalk.

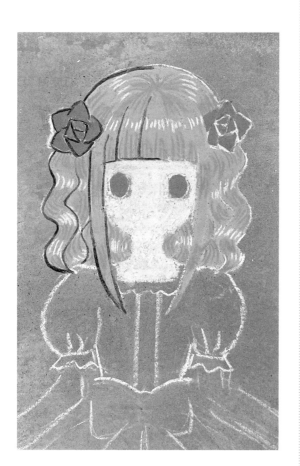

46. Use black for her eyebrows and around her eyes.

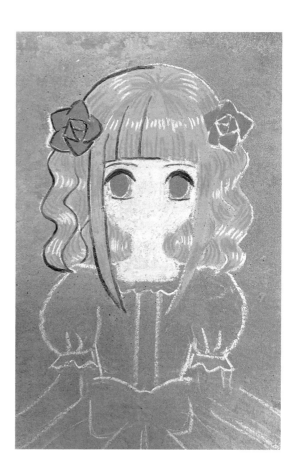

47. Put black pupils in her eyes. She's look-
ing up.

48. Put in her small nose and her smile.

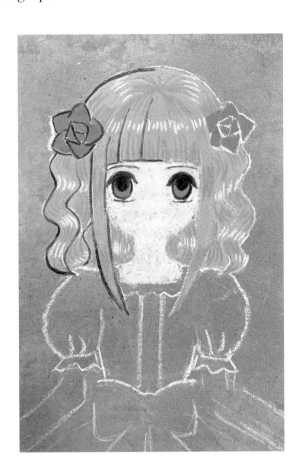

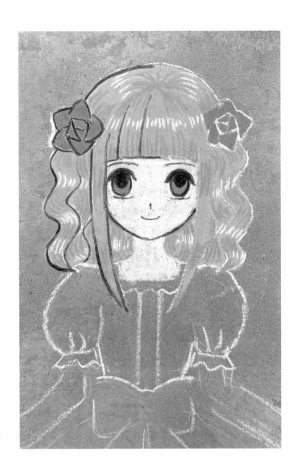

49. Continue to outline her with black chalk.

50. Outline the rest of her hair and the other rose.

51. Add some white to her eyes for a shiny look. Put a little pink on her mouth.

52. Trace the top of her clothing with pink.

53. Make her collar and the lace at her sleeves white.

54. Color in the pink.

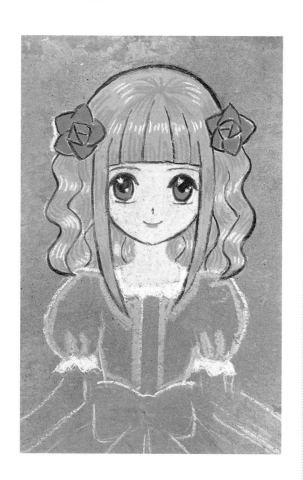

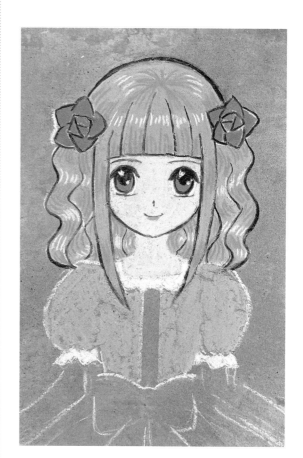

55. Make a red outline between the pink sides of her shirt.

56. Color the red stripe. You can add triangular green leaves to the roses. The green color can be put on her pink hair since it's darker and will cover the pink. The black outlines of the leaves should be drawn after you color the leaves with green.

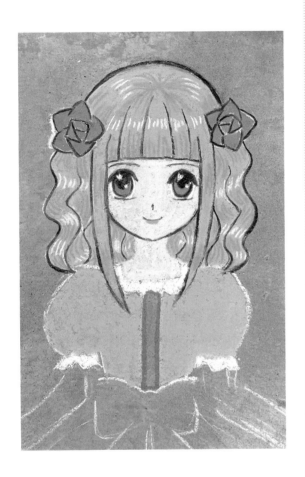

57. Outline her neck and collar.

58. Outline more of the top of her dress.

59. Put two white lines down the red stripe.

60. Start to draw her arms.

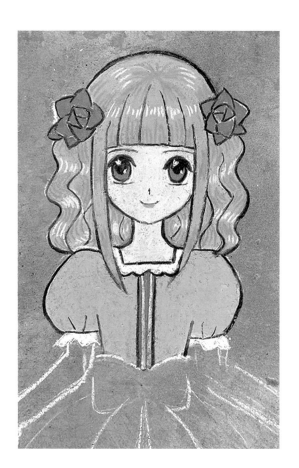

61. Draw her hand. You can see her shorter thumb and two longer fingers. Draw her big ribbon. You can start with the square for the knot, then put in the rest.

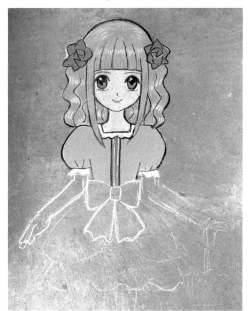

62. Draw her other arm and hand. You can only see her thumb and one finger.

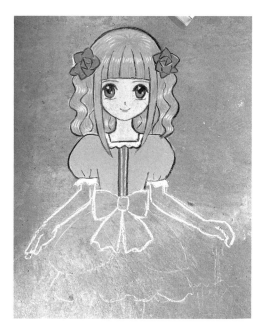

63. Do two big loops for the top of her skirt.

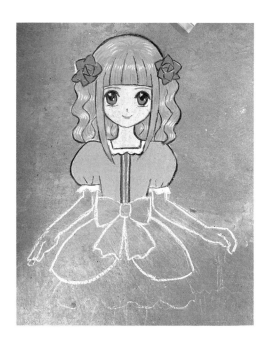

64. Finish her skirt. It waves at the bottom.

66. Begin smudging.

65. Color her skin, then the pink of her skirt, then the red ribbon and red part of her skirt.

67. Start outlining with black.

68. Continue to outline with black.

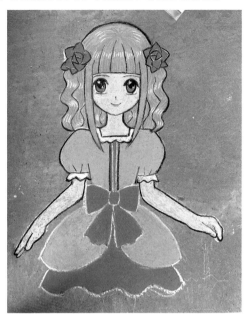

70. Outline the rest of her dress with black.

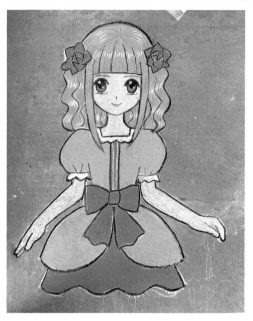

69. Outline the ribbon with black.

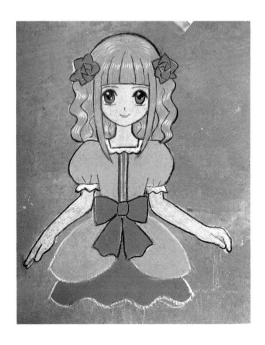

71. Next, draw her legs. She's wearing high socks, so only a little bit of her legs are visible.

72. Draw in the socks, with wavy lace at the top.

73. Add straps and little heels to her shoes.

74. Color the lace white and then color her skin. Then color the purple socks and red shoes.

75. When you're done coloring there, smudge the chalk and add black outlines.

77. Now it's time for her umbrella. It has a long cone, a ruffled top, and a handle that looks like a candy cane.

76. Put some white on the shoes for a shiny look.

78. Color the umbrella alternating light and dark, then smudge, and outline with black chalk.

79. Put black lines over it for creases.

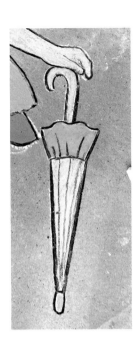

80. Here is your stylish Harajuku girl!

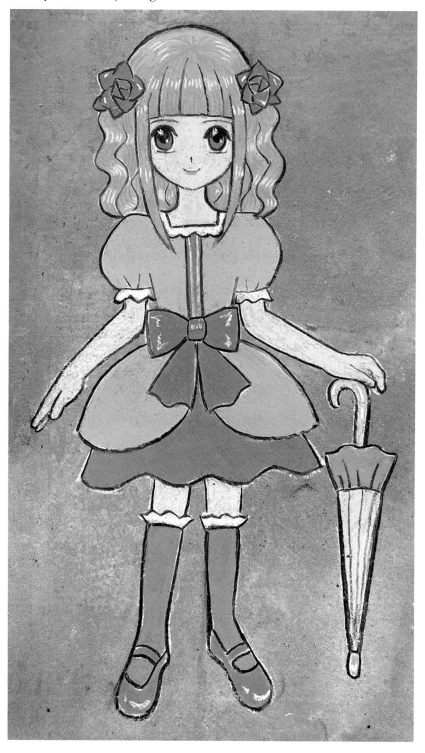

CONCLUSION

Manga are exciting and enthralling graphic novels that delight people in Japan and abroad. Many fans want to share their love of manga in addition to reading it, by attending anime conventions or making fan art. At the same time, chalk art is especially beloved by kids, or by the kid inside all of us. By combining these two artistic forms, we aimed to help you find another unique way of expressing your love of manga and chalk together. By breaking down the steps and discussing techniques like smudging, we wanted to take away the mystery of chalk art and show how fun and accessible it can be.

Thank you for going on this journey with us, and we hope you enjoy filling your sidewalks and driveways with bright, vivid art. Good luck with your art, and keep sharing the manga love!